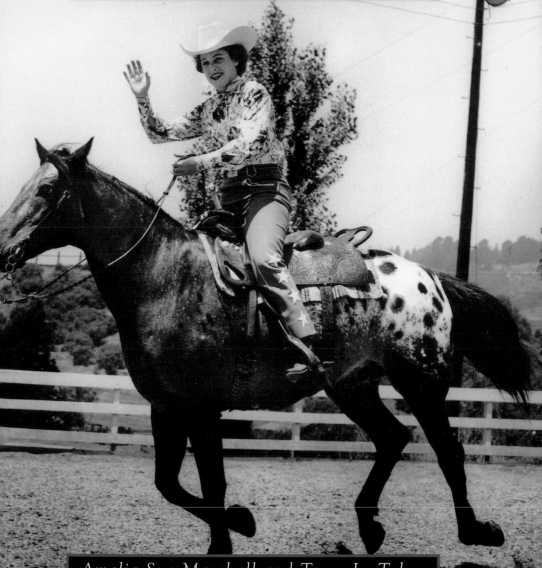

IMAGES
of America

OAKLAND'S
EQUESTRIAN HERITAGE

Amelia Sue Marshall and Terry L. Tobey
Metropolitan Horsemen's Association

IMAGES
of America

OAKLAND'S
EQUESTRIAN HERITAGE

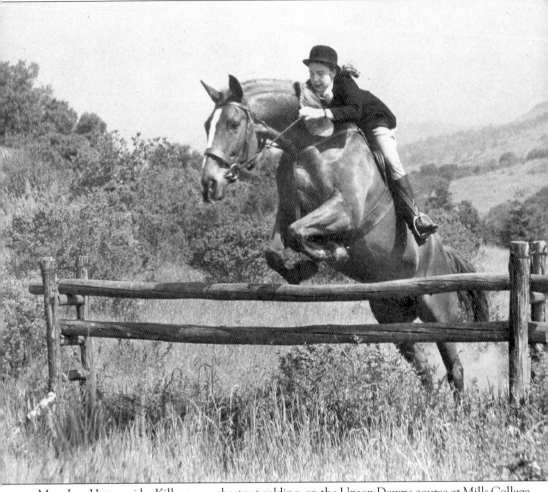

Mary Lou Hutton rides Killarney, a chestnut gelding, on the Upson Downs course at Mills College around 1945. (Courtesy Chris Bearden and Mills College Library.)

ON THE COVER: Loretta Cosca, daughter of Florence and Stanley Cosca, was a trick-riding and trick-roping sensation from the mid-1940s through the late 1950s. She was a card-carrying professional with the Rodeo Cowboys Association (RCA) and performed throughout Northern California. Here she is shown at her parents Skyline Ranch on her beloved Appaloosa, Buckshot, around the late 1950s. Loretta said of Buckshot, "Jimmy Black found him down in the valley; he was a former pony horse off the track. He had the best temperament of any horse I ever had and was my all time favorite mount." Loretta's trick saddle was custom-made for her by saddlemaker Walt Goldsmith. (Courtesy Loretta Cosca.)

IMAGES
of America

OAKLAND'S
EQUESTRIAN HERITAGE

Amelia Sue Marshall and Terry L. Tobey
Metropolitan Horsemen's Association

ARCADIA
PUBLISHING

Published by Arcadia Publishing
Charleston SC, Chicago IL, Portsmouth NH, San Francisco CA

Printed in the United States of America

Library of Congress Catalog Card Number: 2007939184

For all general information contact Arcadia Publishing at:
Telephone 843-853-2070
Fax 843-853-0044
E-mail sales@arcadiapublishing.com
For customer service and orders:
Toll-Free 1-888-313-2665

Visit us on the Internet at www.arcadiapublishing.com

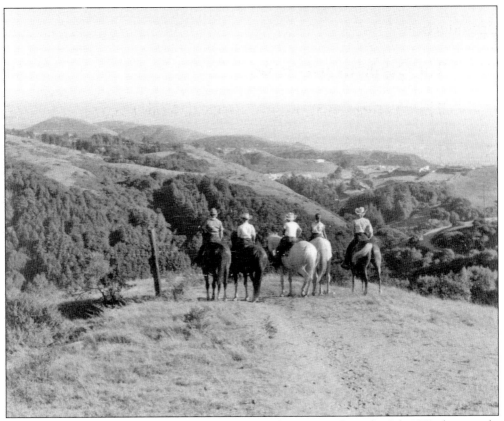

Five riders from Piedmont Stables pause, overlooking the Crossroads, in this July 1959 photograph. Skyline Ranch, Oakland Riding Academy, and Miss Graham's Redwood Riding Stables are located above the rider on the right. The bare hillside to the right will become the Hunt Field. Redwood Canyon lies directly in front of the riders at the bottom of the hill. (Courtesy EBRPD Archives.)

CONTENTS

Acknowledgments

The authors are grateful to those who provided images, personal stories, and hours of their time. These folks made it possible for us to remember and celebrate the magic of Oakland's horse people. We begin with a hearty "thanks pardners" to our top hands: Tiny Black, Loretta Cosca, Lloyd and Ro Graham, Erling and Jan Studley Hansen, and Bruce Orcutt. Thanks also to Judi Bank; Alexis Barba; Louann Bemis; Chris Bearden; Oakland police lieutenant Paul Berlin; Doris Matthews Bianchi; Jack Bisio; Jim Black Jr.; Scotty ("Bobby") Black; John Bosko; Lynne Bosko; Larry Brickell; Fr. Daniel E. Cardelli; Joyce Cosca; Steve and Noel Cosca; Ron Darling; Andy Dietz; B. K. Doyra; Janet Dunlap; Rob Dunlap; Kathy Dunn; Cheryl Fergan; Don Flanigan; Inez Fort; Nanette Franceschini; Mirian Girard; Jeff Graham; Vivian Troxell Graham; Hugh Gregg; Lon Gruenfeld; Laura Guluzzy; Conrad Haas; Sandy Hazeltine; Roger Hicks; Charlie and Vivian Holman; Kari Garaas Johnson; Cecil Jones; John Kirby; Grace Knox; Jack LaLanne; Dennis Lewis; Irene Lorimer; Norman Marks; Dwayne McCosker; officer Kathy Mendez; Bo, Leslie, and Jenny Miller; Debbie Miller; Suzanne Nase; Marlon Willson Oakley; Morris Older; Carol Ormond, DVM; Dorothy Franceschini Rohrer; Mike Rountree; Matt Sciacqua; Mary Souza; Julie Sullivan; Chan Turnley; Yvonne White; and Leslie Wood.

We also wish to acknowledge the help received from Janice Braun at Mills College Library; Steve Lavoie at Oakland Public Library; supervisor D. Rosario, Redwood Regional Park; and Brenda Montano, East Bay Regional Park District (EBRPD) Archive Room.

Terry would like to personally thank the following: my parents, for providing me the best possible childhood and instilling old-fashioned values and love of the Old West; Tiny and Jim Black, for all that you taught me over the years, I have the utmost respect and appreciation; Loretta Cosca, my new but very cherished friend. Finally, many thanks go to Chris Derdivanis for your unending help and support.

Amelia would like to personally thank her kind and patient family: Bill Imler, my husband and best friend, and our wonderful teenagers, Alan, Rosie, and Asia.

A note to our readers: do you have stories and images to share? Please contact us through Arcadia Publishing in San Francisco.

In the words of Jan Studley Hansen, "Horses bring out the best in people."

INTRODUCTION

Imagine the Oakland Hills before there were houses and city streets. Picture rolling hills dotted with oak, manzanita, bay laurel, and madrone trees. Wild poppies, lupines, and monkey flowers provided color. Deer, bobcats, mountain lions, foxes, raccoons, opossums, and skunks found water at hillside springs. Wild berries were plentiful. Native trout and salmon spawned in the streams. In the folds of the hills, the primordial redwood groves were places of worship for the Ohlone peoples.

With the coming of the Gold Rush, ox drivers blazed trails to cut down the ancient redwood trees. Steam mills were set up in Redwood Canyon. Lumber was hauled down Redwood Road to build homes in Oakland and San Francisco. By 1860, all the old-growth redwoods were gone. Later came the ranching families. They planted fruit trees and drove cattle through the hills and meadows that are now Anthony Chabot and Redwood Regional Parks.

The site where Merritt College now stands used to be called Portuguese Flat, where trails converged from all directions. From the Gold Rush onward, Portuguese sailors came ashore to build homes in the hills. There they kept horses to race along the old logging trails. According to legend, the cowboys had the occasional duel on "Portagee Flat" in the 1920s, and there was a designated "hanging tree" over the hill in the town of Canyon. One redwood stump was big enough to serve as a dance floor.

Meanwhile, an old logging town in Redwood Canyon, near the present-day main entrance to Redwood Park, was the destination for bootlegging, prostitution, and tavern brawling. "The Redwood Boys" gained notoriety roaming the area. The foundations and stone stairways of 50 houses can still be seen there.

Among the high society ladies of Piedmont and Oakland, the ability to ride well was considered a social grace as important as proper tea service. They came, first in coaches and later in automobiles, to learn equitation from Miss Beatrice Graham. In 1912, Miss Graham opened her first site, at Twenty-fourth Street and Telegraph Avenue. Later she set up a stable at the present site of John Muir School, at the foot of the Claremont Hotel. Next she moved to Orinda. By the 1920s, she had relocated to Redwood Canyon. Finally she settled near what is now the corner of Skyline Boulevard and Stantonville Avenue, overlooking Lorimer's Oakland Riding Academy, where she remained until 1951.

In 1928, a visionary figure came to Oakland: Cornelia Van Ness Cress. Having ridden with the U.S. Cavalry and worked cattle in Montana, she took over the Lake Aliso Stables at Mills College from Don D. Hayford. Over the next 20 years, Miss Cress built a world-class equestrian program with the assistance of able hands like Erling ("Earl") Hansen.

During the Depression years of the 1930s, Oakland ranchers worked hard and lived simply, counting on the abundance of the land. Money was scarce, and horses were used for work as well as transportation.

Cress foresaw a time when urban development would drive out the horse people—unless they organized themselves to lobby public officials to create a city plan that would retain the horse trails, leaving room for both public and backyard stables. Gathering local ranchers, businesspeople, and well-heeled English riders, Cress founded the Metropolitan Horsemen's

Association (MHA) in 1938 to nurture a united approach to civic involvement and sport among the horse-loving community.

With the coming of World War II, patriotic citizens of Oakland volunteered to do whatever was required of them. Young cowboys enlisted, leaving wives and older men to guard the home front. The Aahmes Shrine Rangers rode forth from their base at Rancho San Antonio on Skyline Boulevard to scan for parachutes coming in over the Golden Gate. Mills College women trained as civil-defense wardens. Recuperating veterans were guests of honor at the Mills College horse shows.

Prosperous years followed the Allies' victory. By 1949, the MHA had built the beautiful Sequoia Arena in Joaquin Miller Park. Horse shows there drew hundreds of contestants and thousands of spectators. Mayor Frank Mott and Councilman (later mayor) Clifford Rishell were among the politicians who presented trophies. Advanced Mills College riders of the Shongehon drill team ascended Horseshoe Creek along the old York Trail, through Dark Canyon (now the Leona Canyon Open Space Preserve), and across Portagee Flat, which was known to the kids as "Windy Gulch."

Civic booster Gus Himmelman promoted parades past his furniture store down Broadway where the Aahmes Mounted Patrol dazzled onlookers with their 50 matching black-and-white pintos and silver-mounted saddles and bridles.

Western impresario Stanley Cosca left the Pinto Ranch and undertook the construction of an ambitious, ultra-modern barn named Skyline Ranch, across Redwood Road from Bob Lorimer's place. All the Cosca children were accomplished riders. Loretta, at a young age, had established a reputation as a trick rider. Steve became a champion rodeo rider and cinematic livestock consultant in Hollywood. The biggest feather in Cosca's cap was his partnership with the legendary Jimmy Black. Jimmy, his wife, Tiny, and their three sons set a tone of Western hospitality at Skyline Ranch, teaching everyone from Hollywood stars to local children to ride.

By now, it was clear that change was in the wind. Under the watchful eye of citizens like Gus Himmelman, Ted Dreyer (of Dreyer's ice cream), and George Hooper (of Hooper's Chocolates), Skyline Boulevard was laid out with a horse trail down the median. The Chabot Park Highlands and Hillcrest Estates neighborhoods featured 1-acre lots, zoned for three horses, with circular driveways large enough for horse trailers. The streets in these neighborhoods still bear the names of the post–World War II equestrian leaders, including Bemis, Dreyer, Graham, Denton, and Robinson.

Between 1954 and 1965, the character of the Oakland Hills was forever altered by the construction of the freeways. Highway 580 plowed right through the Cressmount stables at Mills College, putting an end to a wonderful era. Leona Stables, too, was in the path of the 580 Freeway, and the Studley family had to move when Keller Avenue was extended up to the top of the hill. Gus Himmelman and his family sold their home at 3731 Redwood Road to the city for the Redwood Heights Recreation Center. Hakes Stable, near Woodminster and Maiden Lane, was torn down for the construction of Highway 13. In 1959, the Pinto Ranch on Redwood Road became the site of a school and a baseball field, now called the Pinto Playground.

Nonetheless, riders continued to enjoy the stables that remained. From the White Barn, they rode up Lincoln Avenue, until Head-Royce School demolished the barn in the early 1980s. The Green Barn at Woodminster Square remained until the mid-1990s, when it became an upscale housing subdivision. A move to demolish Skyline Ranch was defeated in 1991 by the Oakland voters. The East Bay Regional Park district now operates Skyline, Piedmont Stables, and Anthony Chabot Equestrian Center. The City of Oakland acquired the old Aahmes Shrine Stables/Rancho San Antonio/Vista Madera site from the Dunn family in 1994 and renamed it City Stables.

Seventy years after it was founded by Cornelia Cress, the Metropolitan Horsemen's Association continues to run horse shows at the Sequoia Arena in Joaquin Miller Park, where the public is always welcome and admission is free.

One

THE OLD BARNS
AND STABLES

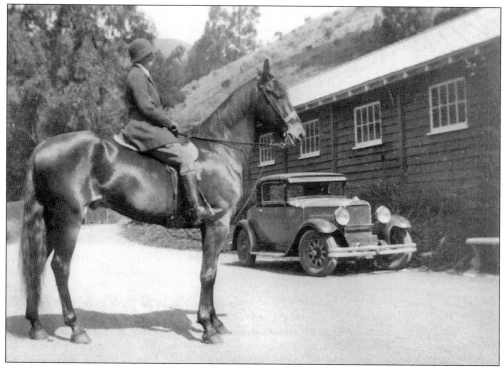

While out for a ride on her favorite horse, society maven Daisy (Mrs. E. A.) Howard takes time out to pose for a quick photograph in front of the Piedmont Trail Club in the late 1920s or early 1930s. The private club was later opened to public boarding when Jimmy Black and Bill Patten took over as managers during World War II. (Courtesy Lloyd Graham.)

The Piedmont Trails Club barn was the destination for pleasure riders wishing to leave the city behind for a day or a weekend. At first glance, this view of the barn from the 1930s looks very similar to its appearance in the 21st century. Of course, the old barn has seen much renovation since the days when Daisy Howard rode there with her friends. Camille Cavalier-Durney's family helped build the stable in the 1920s. (Courtesy Lloyd Graham.)

The Piedmont Trail Club grooms pose for a c. 1928 photograph. Boarders would call ahead to say they were coming. They would find their horses groomed, tacked up, and ready to go when they got there. After they rode, they would hand them off to the grooms and leave. There was a dressing room with a shower. Johnny Hookstraw is in the center of the back row. To the right of him is a man named Al. In the first row on the left is the manager. Other grooms included Fred Eytell, Carla Eytell, Bill Straus, and Hub Badger. (Courtesy Lloyd Graham.)

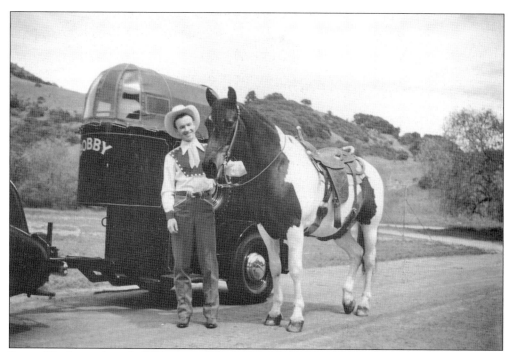

Jimmy Black stands with Bobby, a trick horse he was training. Bobby was purchased in 1941 by Nate Fairbairn and resided at the Piedmont Stables. Nate had the single-axle, single-horse trailer custom-made for Bobby so that he could arrive in style at his horse show and rodeo appearances with Jimmy. Bobby was considered a "high school" horse. That meant that he had learned special gaits, including how to dance and perform other uncommon, technical moves. (Courtesy Tiny Black.)

This 1940s photograph shows Bobby "sitting" in the hills behind the Piedmont Stables. Sitting was a hard trick for horses to perform, and Jim never made them sit for very long. According to Loretta Cosca, Jim's definition of a trick horse was a horse that performed "unnatural acts." Certainly this trick qualified. (Courtesy Tiny Black.)

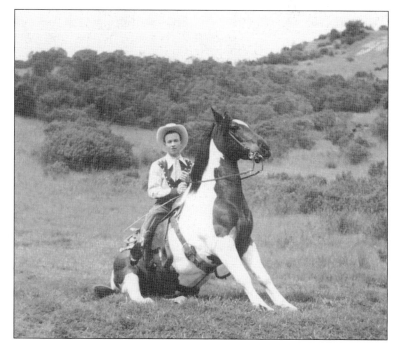

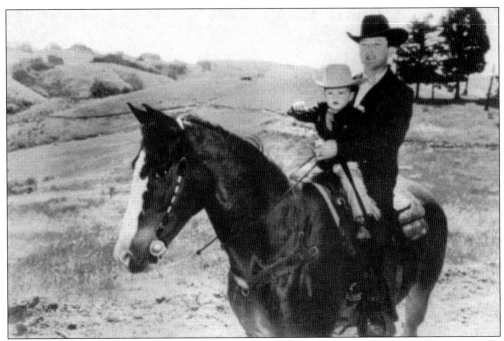

Bill Patten is pictured with his two-year-old daughter, Linda, on Sir Sox in this June 1950 photograph. In the background is the future site of the Hunt Field and the EBRPD Administration Building. Bill managed Piedmont Stables with Jimmy Black in the early 1940s until he took it over on his own when Jimmy left for Skyline Ranch in 1949. (Courtesy MHA Archives.)

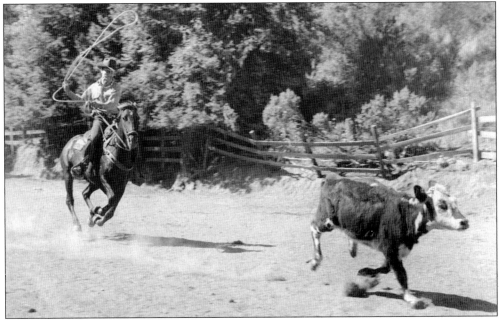

In this 1940s photograph, Bruce Orcutt is shown roping a calf at the Piedmont Stables. Manager Bill Patten was an avid roper and often held ropings for his cowboy friends. The roping arena shown was long and narrow. It has since been replaced by rows of corrals for horses in daytime turnouts. (Courtesy Bruce Orcutt.)

Lloyd Graham is shown during a ride with his son Jeff in July 1959. Lloyd and the Piedmont gang often rode to Moraga to have breakfast at the Ranchhouse restaurant on the weekends. Lloyd said, "They make a real good breakfast." Jeff is riding Lloyd's old Nanninga saddle that he bought in 1939, custom-made for $89. All of Lloyd's kids rode that saddle—Jeff, Heidi, and Wendy. (Courtesy EBRPD Archives.)

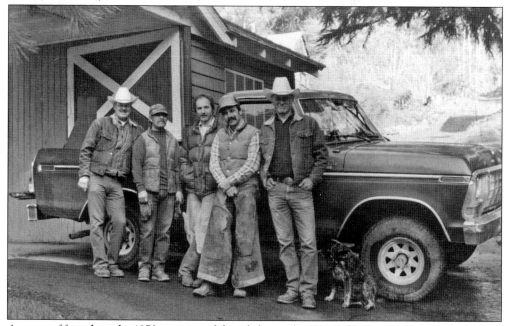

A group of friends in the 1970s consists of, from left to right, Wes Rolf, Russell Marcus (who worked for Lloyd), Rob Dunlap (apprentice horseshoer), Bob Medieros (horseshoer), Lloyd Graham, and Lloyd's ever-faithful dog Stubby. (Courtesy Lloyd Graham.)

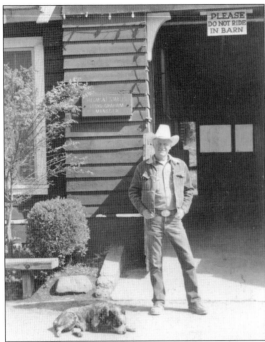

Lloyd Graham took over the Piedmont Stables in 1956 and managed it for 40 years until he retired in 1996. Here he is shown with his faithful dog, Stubby, who Lloyd said was "the greatest dog that ever lived." Lloyd still boards his horse Charlie at the stable and visits often. It would be easily safe to say that Lloyd is one of the most revered of all of Oakland's horsemen. (Courtesy Lloyd Graham.)

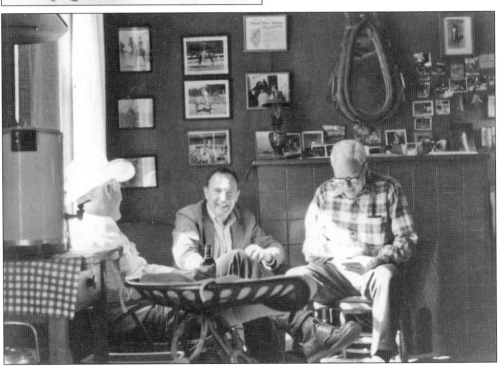

The club room, pictured here, has been a social gathering spot for years, and the coffee pot is always on. Shown from left to right, Lloyd Graham chats with longtime friends Dick Volberg and Bill Haeger. Over the years, boarders have added to the assortment of items in the room. Of special note is the stool made from an old tractor seat and the old horse collar used for pulling a wagon hanging on the wall. (Courtesy Lloyd Graham.)

Lloyd Graham was, and still is, a fine horseman. Over the years, he has trained many a horse to be a solid riding partner for its owner. He is shown on one of his charges in the outdoor arena at Piedmont Stables around 1982. Lloyd was a model for a Purina Pure Pride print advertisement in 1985. He also did a Pac Bell advertisement, which was on television. (Courtesy Lloyd Graham.)

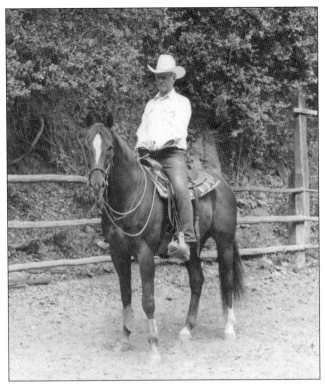

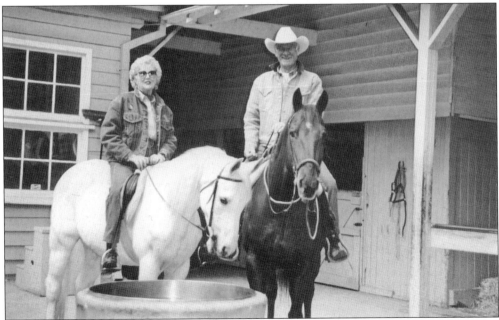

The longtime host and hostess of the Piedmont Stables, Lloyd and Ro Graham, are shown in this April 1999 photograph taken in the courtyard at the stables. Ro is riding her horse, Ace, and Lloyd is mounted on his horse, Charlie. For years, the Piedmont gang would go on group rides in the surrounding hills. In 1968, Lloyd was chosen Horseman of the Year by the MHA and was greeted with a standing ovation. (Courtesy Lloyd Graham.)

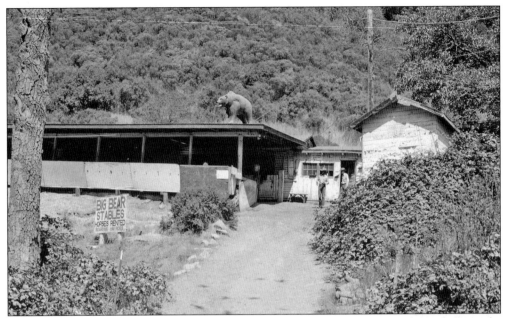

Big Bear Stables was located on Redwood Road east of Piedmont Stables. These photographs from 1971 recall a rough and ready time before insurance rules decimated the horse rental business. Anyone could rent a horse here for about $3 per hour. If the horse was brought back in a sweaty lather, riders had to pay double and walk the horse until it was cooled down. (Courtesy Larry Brickell.)

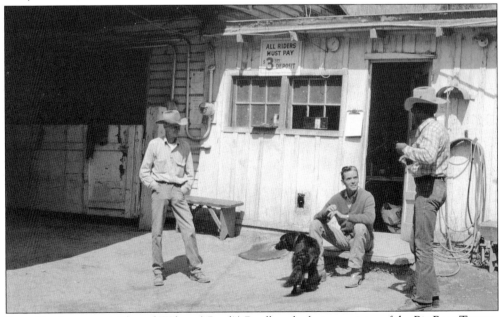

Seated in the center is Elwood Wilson ("Brad") Bradley, the last proprietor of the Big Bear Tavern, across Redwood Road from the stable. He brought the iconic bear statue from Grizzly Peak Stables. Nocturnal rides on the hay wagon were popular with tavern-goers. With a red lantern balanced on the wagon tailgate, wranglers, including Sandy Hazeltine, Dennis Bearden, and the petite Kathy Lewis, drove the team along Redwood Road. (Courtesy Larry Brickell.)

The white shed in the foreground is the Big Bear Stables office. Riders took the trail east (rightward) to the Redwood Park Stream Trail area. Sandy Hazeltine recalls occasional visits from mountain lions to the back stalls of the Bear. (Courtesy Larry Brickell.)

This is a September 1941 advertisement for Canyon Stables, which was located just up the hill from the Big Bear Tavern in Redwood Canyon. Originally Wilkenson's Springs owned the property, which was bought out by Alhambra Water Company. Later in 1947, O. G. Rice was the owner of the stable, which was small, so not much information exists. Up the road, behind the Redwood Roundup, was another small stable called the Hop-A-Long. It rented and boarded horses and was closed by 1947. (Courtesy MHA Archives.)

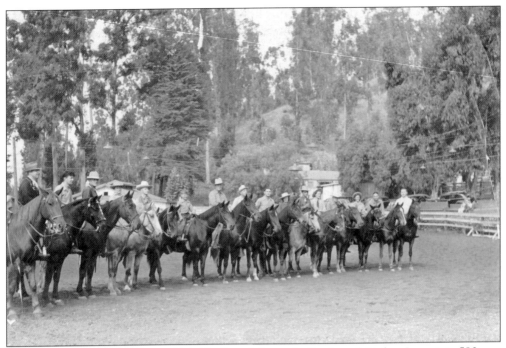

Leona Stables was located near Oak Knoll on Mountain Boulevard. Before Interstate 580 was built, Keller Avenue and the Leona Heights streetcar line ended at the stable's front gate. Earl and Leonore Studley leased 800 acres from the 143rd Field Artillery of the California National Guard from 1937 to 1946. The site had been used as a cavalry field and rifle range. (Courtesy Janet Studley Hansen.)

George Goldt stands with his mount, Sir Tipler, in front of the Leona Stables barn. George bought the buckskin from Eddie Carey and boarded him at Leona. The girl in the dress, at left, is Jan Studley. (Courtesy Janet Studley Hansen.)

Earl Studley proudly displays his black Saddlebred stallion, Odin McDonald. "He was a good looking stallion with a mean temperament," Erl Hansen recalls. Earl stood him at stud, and many horses in the area were his "get" (offspring). (Courtesy Janet Studley Hansen.)

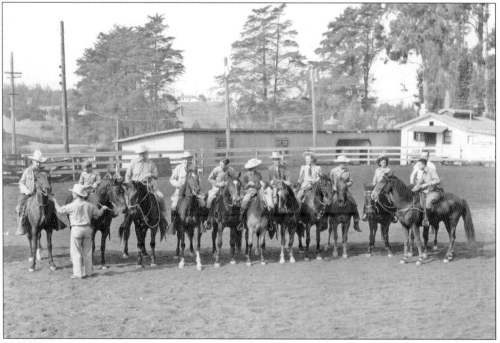

Sheriff's Posse members boarded horses at Leona Stables, and trail rides such as these were popular, followed by western singing and guitar music in the fine clubhouse with its big stone fireplace. When the stable was demolished in 1946 for real estate development, Leonore moved to Rancho Bonita stables, owned by Ken Bemis, located in a eucalyptus grove at the top of Grass Valley Boulevard. (Courtesy Janet Studley Hansen.)

Hidden Valley Stables was operated by Henry and Mildred Matthews from the 1930s into the 1950s. Henry, a member of the Alameda County Sheriff's Posse, raised and sold colts. Mildred had been a childhood playmate of Joaquin Miller's daughter Juanita. The stable was located at 10544 Stella Street, a few hundred feet south of the Oakland Zoo. "We were scared that the wild animals would get loose and come after us," Doris Matthews Bianchi recalls. On Friday nights, her classmates from Castlemont High School would join the family for hay rides down the hill to Foothill and Estudillo Streets. A hot dog barbeque and western singing in the rumpus room completed the evening. Above, Henry rides to the stable gate. Below, Doris Matthews, at age nine in 1941, rides her paint pony. (Courtesy Doris Matthews Bianchi.)

Buck Matthews, Doris's brother, graduated from Castlemont High School in 1946. Three years later, he was recognized as a top jockey at the Golden Gate Fields racetrack. (Courtesy Doris Matthews Bianchi.)

Saddle Horses and Ponies
For Hire and For Sale

JACK'S
Horse Ranch

J. F. RICHARDS, Prop.

Breaking - Riding - Pasture - Box Stalls
Horse Shoeing - Stock Hauling

3900 Joaquin Miller Road Phone SWeetwood 0960

This old business card is from Jack's Horse Ranch in the 1920s or 1930s. Though the address says Joaquin Miller Road, the stable was located just off present-day Skyline Boulevard, near where Stantonville court is now. The ranch was owned by Jack Richards. Jack sold it to Bruce Evander. Later it became Miss Graham's Redwood Riding Stables. (Courtesy Tiny Black.)

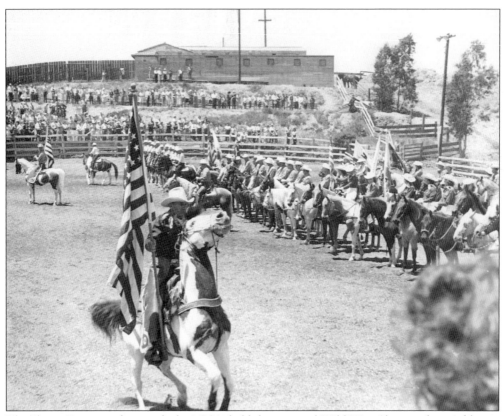

The Shrine Rangers, along with the MHA, held their annual Wild West Show at their stables on Skyline Boulevard on July 18, 1948. The Grand Entry featured the Rangers, led by Capt. Fred L. Bemis; the Alameda County Sheriff's Posse, led by Capt. Ed Carey; the Lari-ettes, led by Capt. Margaret Rukavina; and the Boots and Jeans, led by Lefty Bowes. Above, Harold Cummins is on Flash in the foreground; Stanley Cosca is on Oak Haven Chief at the far left. Below, a skit depicting life in the early West was the highlight of the show. Performers included Louie Barrious, Jim and Scotty Black, George and Kay Walling, Stan and Florence Cosca, Jim Myers, Don Marquis, Elsa and Gus Himmelman, Archie and Opal Brown, Margaret and Frank Rukavina, Harold Cummins, Bill Patten, and Dan Street. The original Grass Valley Stage, rebuilt by Ken Bemis, was used in the skit. (Courtesy Loretta Cosca.)

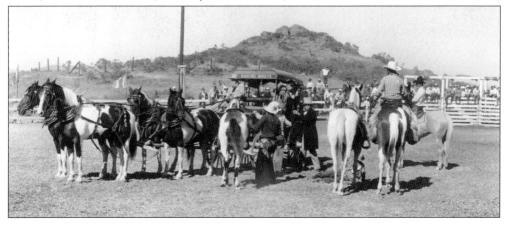

The Shrine Stable was owned by Fred Bemis, founder of the Shrine Rangers, from 1948 to 1965. The Bemis family owned restaurants, including Dave's Coffee Shop at Forty-second Street and Broadway, since the 1930s. The highest peak on the property was named Beacon Hill after the signal light used during World War II to guide mail planes. During the war, the Shriners left when the army was stationed there. Jim and Tiny Black stayed in the caretakers' house. Tiny remembers that Jim Black Jr. ("Butch"), then just six or seven years old, would march with the soldiers every morning after reveille. The stable was bought by Don Lawrence and named Bayview Stables. It became Rancho San Antonio in 1965 when Ron York took it over. The Dunn family bought it in 1973 and named it Vista Madera. It is now owned by the City of Oakland and called City Stables. (Courtesy Kathy Dunn.)

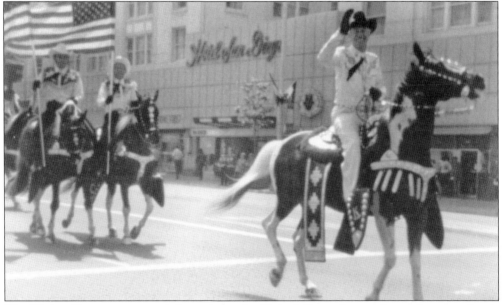

The Shrine Rangers appeared throughout the United States in parades and mounted-unit competitions, notably the Rose Bowl Parade in Pasadena and the Grand National Rodeo at the Cow Palace. They rode in both the Eisenhower and the Carter inauguration parades and appeared in the film *The Right Stuff* about the Mercury astronauts. They were an annual feature of the East-West Shrine Game, played at San Francisco's Kezar Stadium. The mission of the Shrine Rangers was to publicize the work done by the Shrine for the benefit of crippled children through the Shrine Hospital. The Shrine had a large clubhouse on the property that they used for social gatherings and to display their numerous trophies. Leading the Rangers at the Rose Bowl parade is Capt. Ken Rudd. (Courtesy Wally Sousa.)

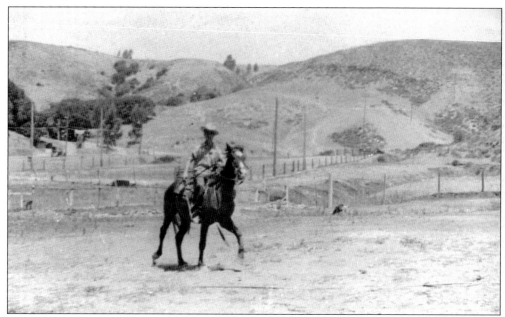

William Brown is shown riding a horse in the pasture that would later become the Pinto Ranch. At the time of this late-1930s photograph, it was just a small private ranch. Redwood Road is visible in the background, and Crestmont Drive veers off to the left. The barren hill is now covered with houses, and the open field is now the Pinto Playground. (Courtesy Tiny Black.)

Tiny Black sits on the gate alongside her younger brother William ("Ted") on the old ranch Tiny and her husband, Jimmy, rented in the late 1930s. In just a few years, the Pinto Ranch would be built on the property. Across Redwood Road is the old house on the property that would soon become the Wagon Wheel Ranch. Then just a toddler, Jim Black Jr. tries out "climbing." (Courtesy Tiny Black.)

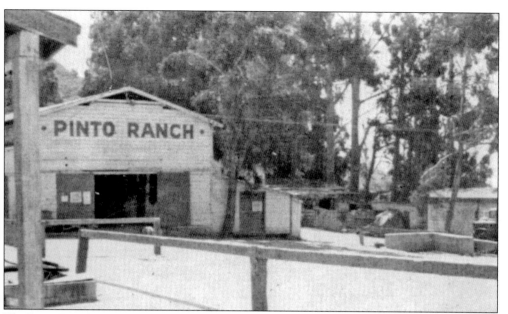

The Pinto Ranch was built by cowboy singer Dude Martin in the early 1940s. Harold Cummins and silent partner Stanley Cosca were its second owners. Bruce Orcutt and Lou Albert owned it around 1950. The Pinto Ranch had a roping arena, clubhouse, blacksmith shop, and saddlemaker Don Bentley's shop. It was a sad day for local horsemen when the barn was finally demolished on April 13, 1959, to make way for the Carl B. Munck School. (Courtesy MHA Archives.)

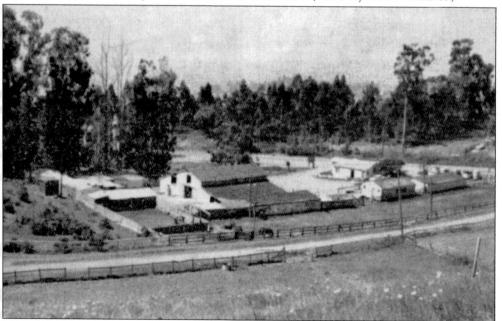

The Pinto Ranch is shown from the hillside pasture facing west in May 1959. The road in the middle of the photograph above the building is Redwood Road. The long roping arena is shown next to the barns, and the small corral on the end at the left was used for breaking colts. The ranch housed approximately 70 horses. The dirt road crossing the foreground led to the Diamond T Ranch, which later became the Diamond B. (Courtesy MHA Archives.)

Stanley Cosca on Stormy, left, and Harold Cummins on Flash pause from their ranch chores for a 1940s photograph. At that time, Pinto horses were gaining in popularity. Stan and Harold owned and bred quite a few, hence the name Pinto Ranch. It must have been quite a sight to see the colorful horses as a herd in the pasture. (Courtesy Loretta Cosca.)

Harold Cummins shows off his registered Pinto stallion, Flash, in this 1940s photograph taken at the Pinto Ranch. Harold used Flash for roping and ranch work and stood him for a stud fee of $20 in 1945. Behind Flash are two of the horse trailers typical of the era; many had open tops like the one on the right. (Courtesy Loretta Cosca.)

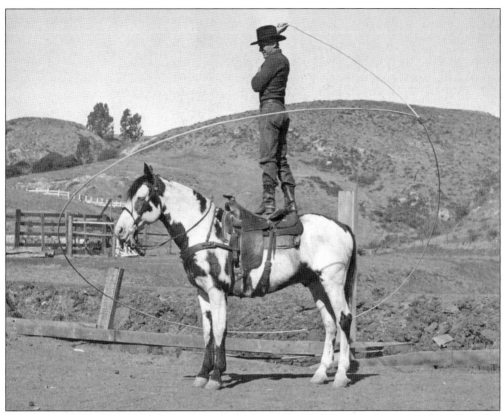

Someone once said, "Harold Cummins *was* the Pinto Ranch." Stanley Cosca may have been his silent partner in the ranch, but it was always known as Harold's place. In this 1940s photograph, Harold is shown performing a "big loop" while standing on his Pinto stallion, Flash. Though Harold was not a trick roper per se, he was a very fine calf roper and could certainly handle a rope. Before buying the Pinto Ranch, Harold boarded at the Wildwood Stables with Johnnie Curry. (Courtesy Loretta Cosca.)

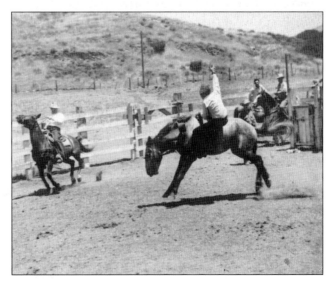

Cowboys at the Pinto Ranch are shown during a ranch rodeo in the 1940s. The ranch held frequent rodeos with calf roping and bronc riding. Stanley Cosca's daughter Loretta performed trick riding from a very young age. Things got a little wild when people decided to sit on a cowhide and be dragged behind galloping horses in a race they named "surf riding." Don Flanigan said of the times, "It was real western back then; you could do most anything you wanted to do." (Courtesy Loretta Cosca.)

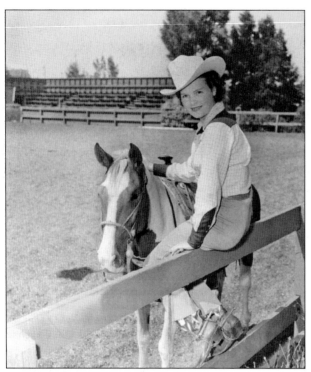

Florence Cosca is shown seated on the fence with her new, registered Pinto, Oak Haven Chief. Florence saw an advertisement for Chief in the Pinto Horse Society Registry and drove to Ventura with a friend to buy him. This 1940s-era photograph was taken during a horse show at the Cressmount Arena at Mills College. (Courtesy Steve Cosca.)

Like mother, like daughter—here young Loretta Cosca practices tricks with her own registered Pinto named Poppy. Despite her young age, Loretta was already an accomplished equestrian. Behind her, above to the right, an old car can be seen on what was then old Redwood Road. (Courtesy Loretta Cosca.)

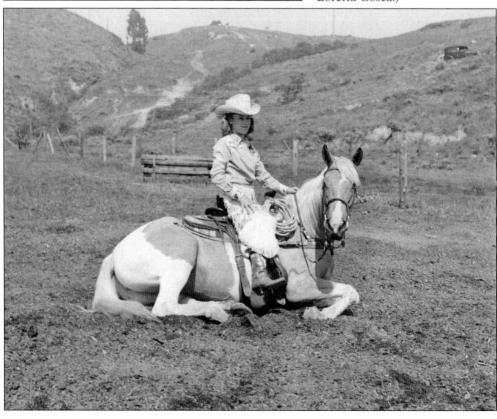

Margaret Rukavina stands with her horse in front of the clubhouse at the Pinto Ranch in the 1940s. The clubhouse had a long porch in the front where a person could sit and have a soda pop from the machine. Saddlemaking partners Don Bentley and Dave Silva had a shop in the building, where they made fine handmade, custom saddles. Later Don owned the shop alone. (Courtesy Loretta Cosca.)

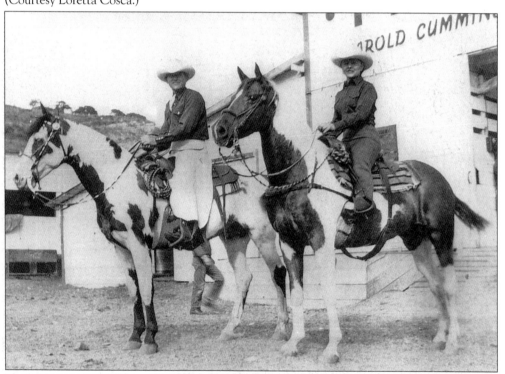

Harold Cummins is shown under the sign that bears his name at the Pinto Ranch. Harold is riding his Pinto stallion, Flash, while his wife, Carmelita, is riding her pretty mare, Sparkle. Both horses were registered with the newly formed Pinto Horse Society, which was started by George M. Glendenning in 1942. (Courtesy Loretta Cosca.)

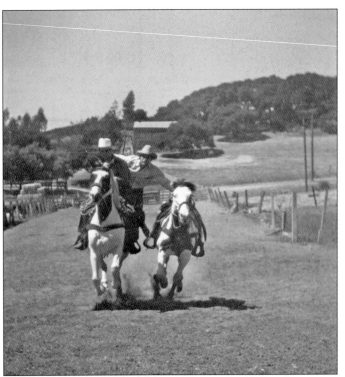

Stanley Cosca (left) "picks up" Harold Cummins (right) as they practice rodeo skills needed for bucking broncs and bulls in the roping arena at their Pinto Ranch. Stanley and Harold went to Roosevelt High School together and were born only four months apart. Stanley owned and managed Stanley's Market at Thirteenth Avenue and Foothill Boulevard from around 1929 to 1952. The main barn at the Wagon Wheel Ranch, located at 4951 Redwood Road, is visible in the background. (Courtesy Loretta Cosca.)

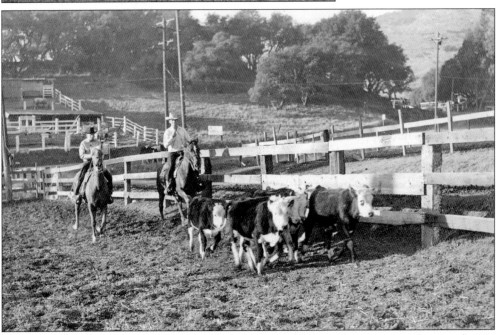

Two cowboys are shown moving calves during a roping practice at the Pinto Ranch around 1950. On the right is Bruce Orcutt, and on the left is his pal Lou Albert. The two were then partners in the ranch. Directly behind them, across Redwood Road, are the upper corrals of the Wagon Wheel Stables. The upper right of the photograph shows the driveway of the Wildwood Stables, now Crestmont Drive. (Courtesy Bruce Orcutt.)

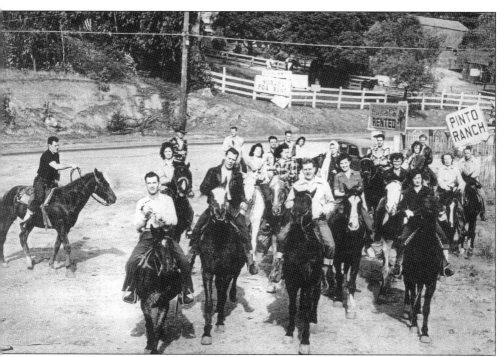

A 1950s group of "dude" (rent string) riders assemble in the Pinto Ranch driveway. One owner of the ranch, Bruce Orcutt, leans against the pole in the background. Across Redwood Road is the Wagon Wheel Ranch. Its main barn with eight box stalls and a big hayloft is shown in the upper right. The small shack below was a hot dog stand run by Lari-ettes member Gloria Isola. (Courtesy Bruce Orcutt.)

Ollie and Johnnie Curry are shown on their registered Quarter Horses in this photograph from April 1950. Ollie is riding Comet, while Johnnie is riding Red Wing. The Currys owned the popular Wildwood Stables nestled in the oaks on Redwood Road, now the corner of Crestmont Drive. Tragically, soon after this photograph was taken, Johnnie was killed instantly in a horse-racing accident at the Livermore Rodeo. Earl Caudle took over as manager and ran the stable until it was demolished in the late 1950s or early 1960s. (Courtesy MHA Archives.)

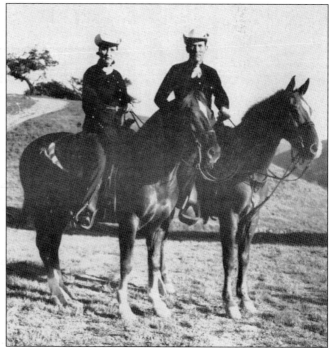

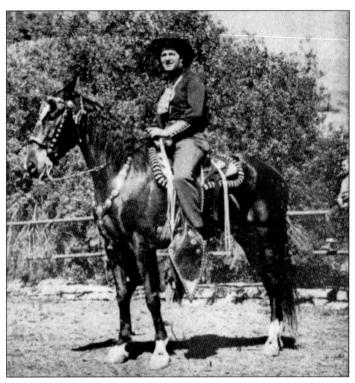

Archie (pictured) and Opal Brown's ranch was at the bottom of Portuguese Flat. In 1947, fourteen MHA members, including Ollie and Johnny Curry, Dutch Cummings, and Sheriff's Posse members Art Palmer and Manual Sousa, met in the evening at Brown's ranch for a mounted coon hunt. Maurice Senecal furnished two hounds, and Archie brought his beagle. The dogs were released at Portuguese Flat and went baying off into the night. No coons were found, but everyone enjoyed themselves. (Courtesy MHA Archives.)

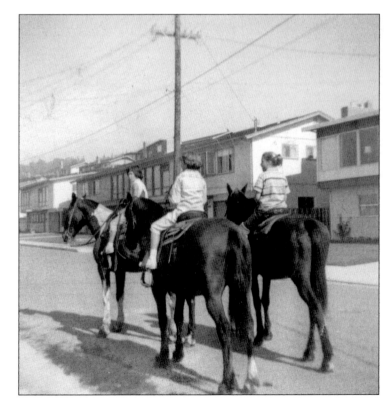

This snapshot from 1958 captures the pivotal time when Oakland's Wild West collided with the world of postwar housing tracts. Girls from Rishell Drive saved up their babysitting money until they had $3.50. Then it was off to the nearby Wagon Wheel, Wildwood, or Pinto Ranch for an hour of riding in the neighborhood. Here, from left to right, Lynne Bosko is riding Cricket, Lorraine Cohen is on Johnny, and Diane Shahoian is on Tex. (Courtesy Lynne Bosko.)

Above, Bruce Orcutt's 1946 advertisement for the Wagon Wheel Ranch said it all: if it had anything to do with horses, Bruce could do it. Below, Bruce is shown with his award-winning Registered Quarter Horse stallion, Joe Jones Jr., in this 1950s photograph. Bruce owned the Wagon Wheel from 1945 to 1947. Around 1949, Bruce became partners with Lou Albert in the Pinto Ranch and took over the rent string from Roy Risi. In 1952, Bruce took over the horse concession at Peralta Amusement Park from Johnny Curry, where he ran pony and cart rides for the children. Bruce bought a miniature stagecoach from Frank DiGrasse. He pulled the Overland Stage with two ponies and gave rides to delighted children. He owned the White Barn property from 1952 to 1958. He sold it to pursue the horse-racing industry in Pleasanton. (Above, courtesy MHA Archives; below, courtesy Bruce Orcutt.)

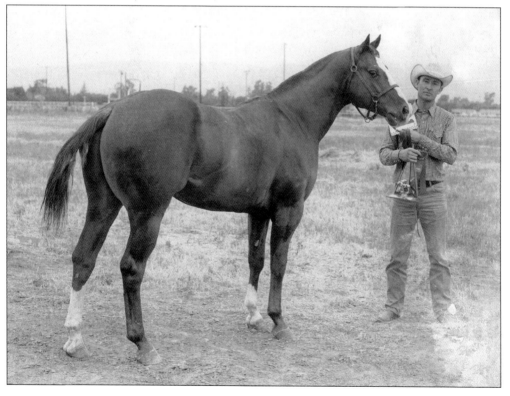

33

HORSES BOARDED
(Box Stalls)
HORSES RENTED

HAKE'S
STABLES

1st hr..$1.00..2nd hr..50¢
FLOODLIGHTED ARENA
2923 Mountain Blvd..Ph. FR 9125
(At Crossroads below Joaquin Miller's)

Hake's Stables was originally owned by Walter Hamby. The Townsends owned it next. Over the years, it went through a succession of owners and was also called Happy Hobby, when Pat and Claude Jones bought it; Don Evan's; Lew Helm's; Mountain Riding Club; and Oak Creek Riding Club. Highway 13 spelled the end of the stable, which was located near the Lincoln Avenue overpass. (Courtesy MHA Archives.)

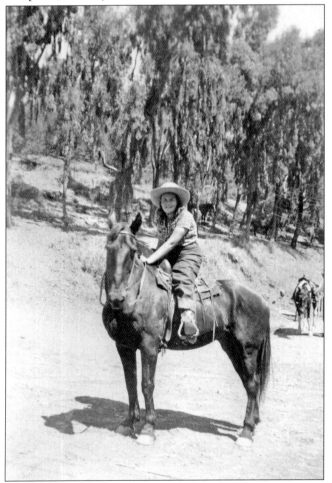

From the time she was a young girl, Mona Tobey was in love with horses. She, along with friends Roland and Roger Hicks, would save money from mowing lawns and rent horses at Hake's Stables. In this August 1942 photograph, Mona is riding Eagle and appears to be posing where Highway 13 is now located. (Courtesy Terry Tobey.)

Tobey's Gulch, owned by Earl and Mona Tobey, is shown in this c. 1954 photograph. The property was purchased in the 1940s and turned into a ranch. The barns and corrals were all built by Earl, with help from Mona and friends. The Tobeys raised Appaloosa horses, Shetland ponies, chickens, rabbits, and peacocks. They had numerous dogs and cats. A fruit orchard was planted in the 1960s. (Courtesy Terry Tobey.)

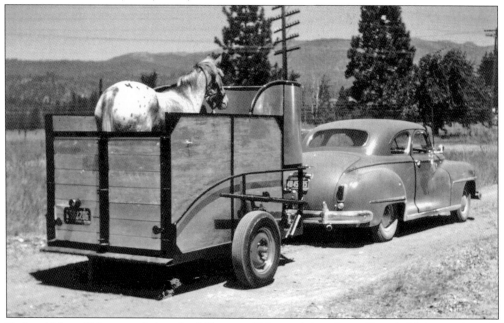

Earl and Mona Tobey traveled to the fifth annual National Appaloosa Show held August 8, 1952, at the Plumas County Fairgrounds in Quincy, California. There they purchased a Foundation mare named Fancie No. 336 to use in their breeding program. At the time, this rig was state-of-the-art. Today no one would dare think of hauling in a single-axle, open-top trailer. (Courtesy Terry Tobey.)

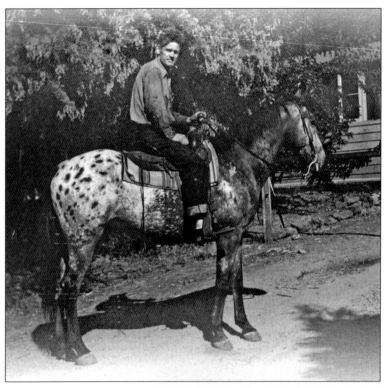

Earl J. Tobey is shown riding his prized Appaloosa gelding, Roper, at his ranch, Tobey's Gulch, around 1952. As the first Appaloosa in his area, Roper was quite a novelty. Earl bought him from a magazine advertisement and had him shipped out to California from the Midwest in the early 1940s. Earl was a mechanic by trade and owned several gas stations named Tobey's Garage. (Courtesy Terry Tobey.)

Mona Tobey is shown on her mare, Cindy, at Tobey's Gulch in 1949. A lifelong horse and animal lover, Mona's dreams came true when she married Earl Tobey and started living the ranch lifestyle she always dreamed of. The couple rode the Oakland trails together for many years. Mona, an award-winning leather craftswoman, was taught by master saddlemaker Don Bentley at the Pinto Ranch. (Courtesy Terry Tobey.)

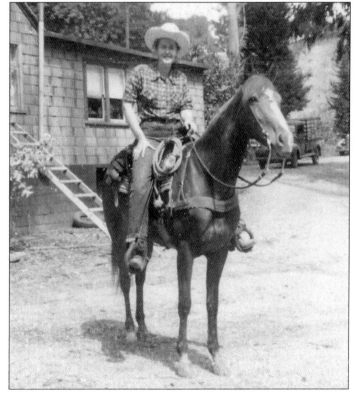

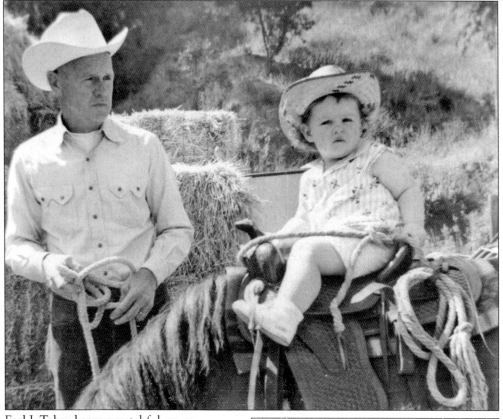

Earl J. Tobey keeps a watchful eye on his 14-month-old daughter Terry, who is riding one of the family's ponies. A lifelong equestrian himself, Earl began Terry's riding career at one month old by holding her in front of him on his Appaloosa, Roper. Over the years, the pair enjoyed riding together in the hills, Terry on her gelding, Rusty Sunshine, and Earl on his mare, Wa Wa Wampum. (Courtesy Terry Tobey.)

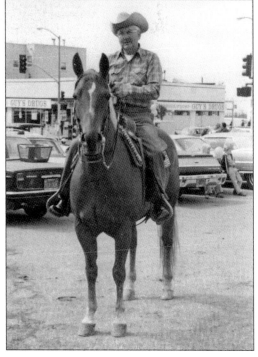

Louie Barrious, riding his Quarter Horse mare, Annabelle, is shown in the Action Laundry parking lot at the corner of Thirty-fifth Avenue and MacArthur Boulevard. The pair was preparing to ride in the Laurel Merchants Parade in this August 1977 photograph. Louie ran both White Barn and Green Barn from the 1960s to the 1980s. Louie was a mechanic for Columbo Bakery for many years. In the 1950s, he was a sergeant in the Oakland Mounted Police Reserve. (Courtesy Julie Sullivan.)

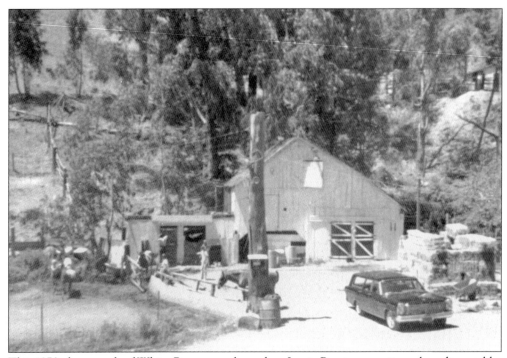

This 1970 photograph of White Barn was taken when Louie Barrious ran it as a boarding stable. It was common to see riders and their horses going up and down Lincoln Avenue to get to the trails in Joaquin Miller Park. The property has since been acquired by the Head Royce School. The barn and surrounding paddocks have been replaced by an athletic field and parking lot. (Courtesy Julie Sullivan.)

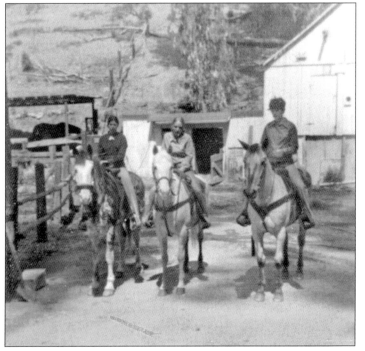

Three friends from White Barn are preparing to leave on a trail ride, perhaps to an MHA Playday at Sequoia Arena. Shown from left to right in this May 1973 photograph are Diane Purdy on Clyde, Leslie Miller on Dipper, and Janet Myers on Cherokee. (Courtesy Janet Dunlap.)

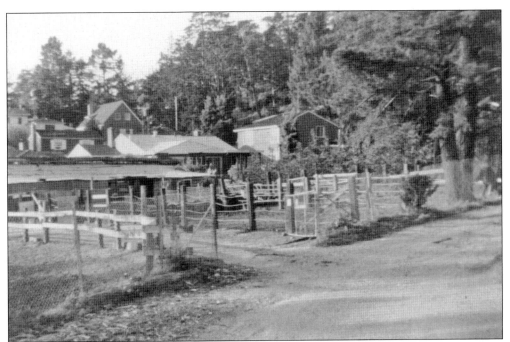

The entrance to Green Barn Stables is pictured in this 1970s photograph. The barn was located on Werner Court, behind the popular Don and Ann's restaurant. Joe Huber ran it from the 1930s to the 1940s, Jean Finney had it in the 1950s, and Louie Barrious ran it from the 1960s through the 1980s. The stable was demolished in the 1990s for a housing development. (Courtesy Nanette Franceschini.)

One of the Louie Barrious's early boarders at White Barn, Julie Catron, is shown with her horse Master Sergeant. Julie is displaying the ribbons she and Sergeant won at the 1977 Hunter Trials at the Hunt Field. Julie was president of the MHA Juniors in 1971. (Courtesy Julie Sullivan.)

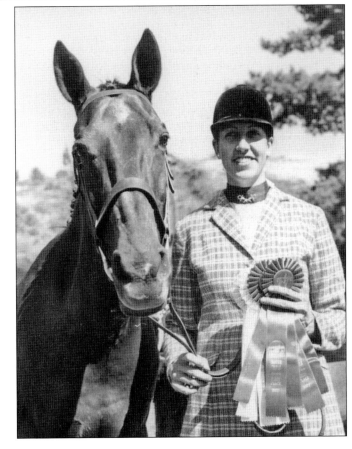

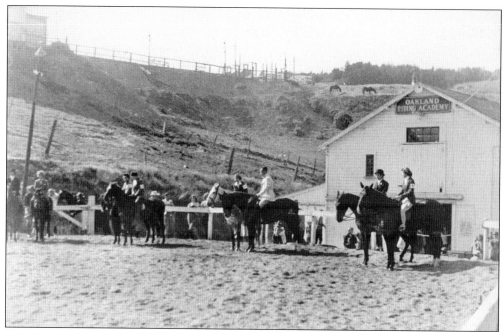

Oakland Riding Academy was acquired by the Lorimer family around 1940. Don Evans managed it for a few years. Bob Lorimer took over the operation in the mid-1940s and attracted an affluent clientele. Above, riders enjoy the west arena at Lorimer's before it was covered around 1964. Miss Graham's Redwood Riding Stables can be seen above and to the left on what is now Pembroke Court. Below, Bob Lorimer adjusts a rider's stirrup length for a trail ride. (Courtesy Irene Lorimer.)

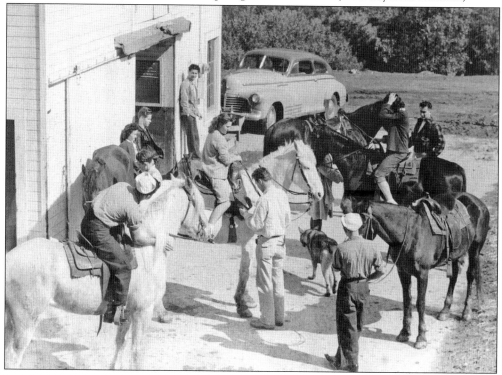

Lorraine Lorimer was the mother of four daughters and was a devoutly religious person. In the image above, she appears to be on the trail near a Mills College horse show. Bob Lorimer was a creative person who was fond of the finer things in life. He came from a distinguished family of Scots heritage. His grandfather, John W Lorimer, founded the Lorimer Diesel Engine Company of Oakland and donated a trophy in 1927 to the pilot of the fastest motorboat in Lake Merritt. Bob's father, J. Hamilton Lorimer, was a boxing promoter who managed fighter Max Baer. Bob's decorative stone masonry and landscaping projects can still be seen on the grounds of his old riding academy. (Above, courtesy Irene Lorimer; at right, courtesy MHA Archives.)

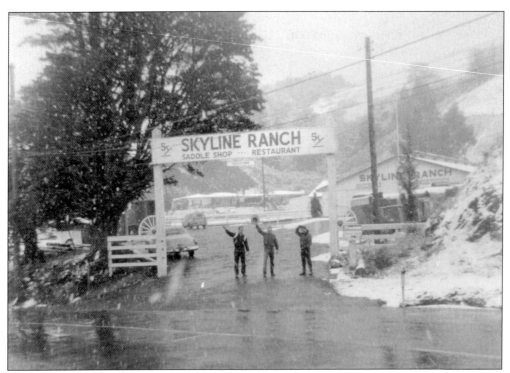

Three cowboys wave from the entrance to Skyline Ranch during a rare snowfall in the 1950s. Many accidents occurred that day as drivers unfamiliar with driving in snow skidded off the steep portion of Redwood Road. (Courtesy Steve Cosca.)

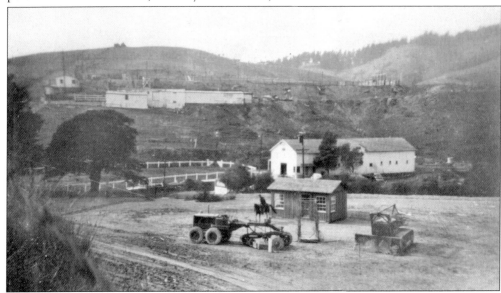

This Skyline Ranch photograph from March 1949 looks toward the Hunt Field area. The large white barn in the middle is Lorimer's Oakland Riding Academy. The long white barn at the top is Miss Graham's Redwood Riding Stables. The riding ring is above the stables, the present site of the Hunt Field arena. The small building near the tractor is close to where the Skyline Kitchen would soon be built. (Courtesy Loretta Cosca.)

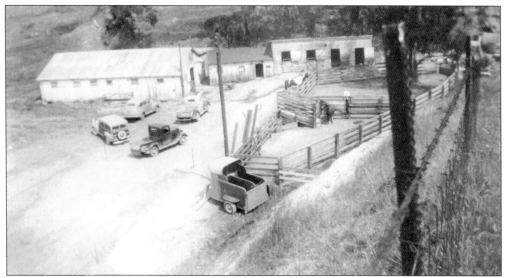

Skyline Ranch is shown in April 1949 soon after the Coscas bought the 8-acre property from Harry Menecucci and before construction had begun on the new facilities. The barns and corrals are essentially the same as when Miss Graham leased the ranch through the mid-1940s. (Courtesy Loretta Cosca.)

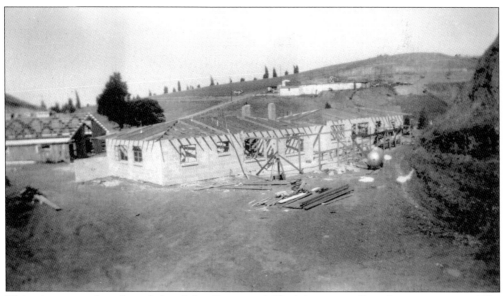

This view was taken from behind the Cosca and Black homes, still under construction. The homes were exactly the same with just a reversed floor plan. They were adjoining with a common courtyard. In the distance, one can see the two driveways that meet at Miss Graham's Redwood Stables. Visitors could enter from either Redwood Road or Joaquin Road (now called Skyline Boulevard). (Courtesy Loretta Cosca.)

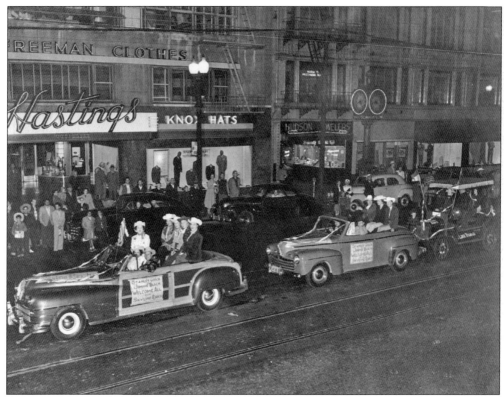

The Cosca and Black families and their friends participated in a night parade in August 1949 to announce the opening of the new Skyline Ranch. Earl Nanninga is driving the "Woody." The car to the far right is an old crank Ford "Tin Lizzie" surrey with fringe on top. The signs on the cars read: "Stanley Cosca and Jimmie Black—Welcome all to the Skyline Ranch." (Courtesy Loretta Cosca.)

Two successful cowboys, Jimmy Black (standing) and Stanley Cosca (on horseback), take time to discuss the ranch they recently created. Stanley was the owner and manager of Skyline Ranch, and Jimmy was a well-known and talented horse trainer. Their families lived next to each other on the ranch for many years, in houses that Stanley built especially for them. (Courtesy Loretta Cosca.)

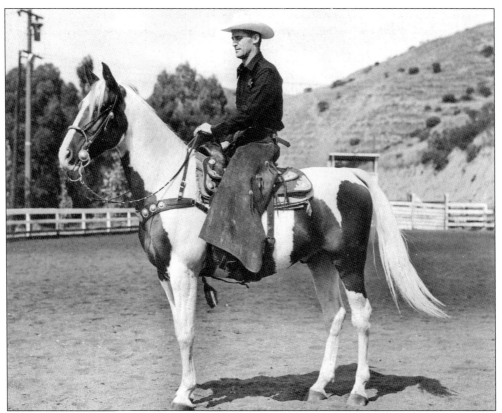

Stanley Cosca is shown at his ranch mounted on Oak Haven Chief, No. 98 Pinto Horse Society. Chief was sired by the Arabian Ferdin No. 613 and was foaled by a Pinto mare. A sorrel-and-white Tobiano stallion, Chief was foaled June 22, 1939. (Courtesy Loretta Cosca.)

Skyline Ranch was built in 1949 by Walt Leatham for Stanley Cosca, a retired food merchant. The property was originally owned by Maxfield and Coffee, then by Harry Menecucci, who sold it to Stanley. Miss Graham's stable had been located there for years. The new ranch facilities included 60 stalls, tack rooms, wash racks, indoor ring, club room, restaurant, saddle shop, corrals, and a 100-acre pasture. The outdoor arena was 100 by 250 feet and had calf roping and bucking chutes at the far end, shown in this 1955 image. The invaluable ranch helper for many years was Lloyd DeRusha, member and caller for the Boots and Jeans Square Dancers. (Courtesy MHA Archives.)

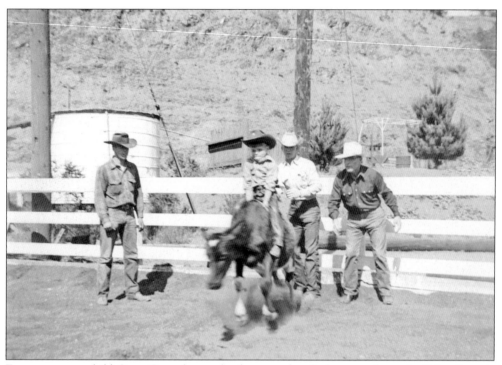

Even as a young child, Steve Cosca knew what he wanted to do: he wanted to rodeo! Here Steve is shown riding a calf at his family's Skyline Ranch in the early 1950s. (Courtesy Loretta Cosca.)

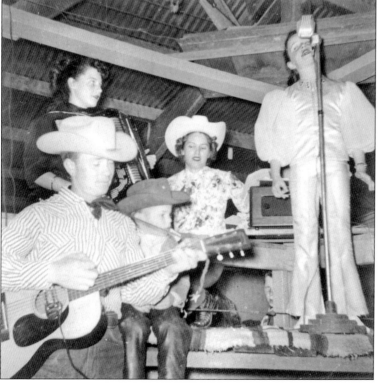

At a Skyline Ranch Christmas party in the early 1950s, Jim Black played guitar while Sandy Black sang. Little Steve Cosca is behind Jim, and Loretta Cosca is wearing a flowered shirt, behind Steve. Jim was previously in a band called the Pee Wee Hillbillies, which was featured on the radio. (Courtesy Steve Cosca.)

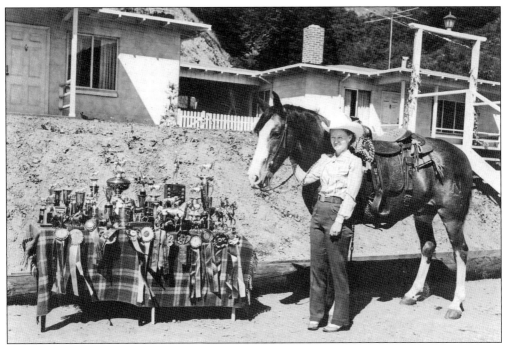

Tiny Black poses with her good horse, Rabbit, and the many awards she has won with him. The photograph was taken in front of her home at Skyline Ranch in the early 1950s. (Courtesy Tiny Black.)

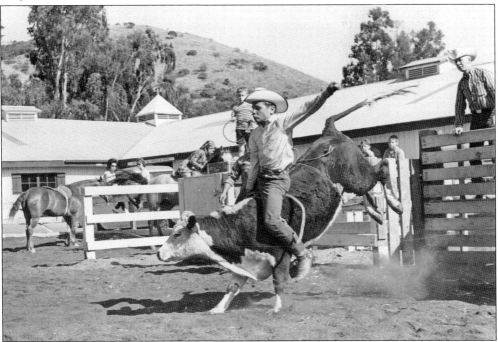

As a young boy, Steve Cosca was perfecting his form riding calves, preparing for the day when he could ride broncs and bulls in the RCA. Jimmy Black looks on from the right side fence. (Courtesy Loretta Cosca.)

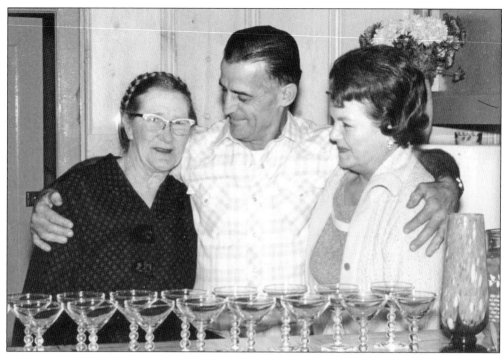

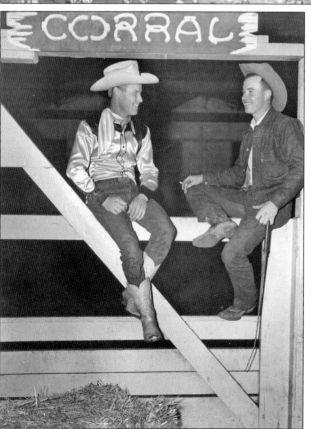

Ethel Colbert was cherished by her friends Stanley and Florence Cosca. Ethel came to live at Skyline Ranch in 1948 after working at the old Leona Stables and Studley Ranch. Stanley said she would always have a home at Skyline, and he kept his word. Ethel was honored with a surprise birthday party at which Stanley and Florence gave her a special apartment they built especially for her in the barn. These quarters are now the office of the Redwood Hills Pony Club. (Courtesy Vivian Graham.)

The two trick-riding brothers, Scotty Black on the left and Jimmy Black on the right, take time to pose on the indoor "corral" gate at Skyline Ranch in the early 1950s. (Courtesy Tiny Black.)

Jim Black, in addition to being a legendary horse trainer, was also an accomplished artist. Jim did sketches for years of the Old West in the style of Charles Russell and in 1957 took up oil painting. Jim enrolled in a one-semester course at the California College of Arts and Crafts, which helped him to develop his natural talent. Almost every horseman in the area had Jim do a painting of their horse. (Courtesy MHA Archives.)

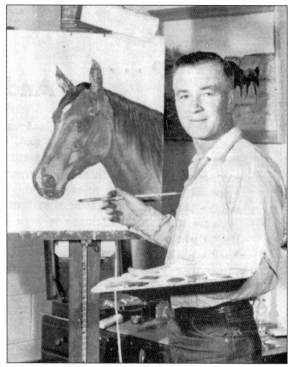

Five good friends from Skyline pose for a photograph in front of a decorated stall at the Cow Palace in the 1950s. From left to right are Jim Black, Stanley Cosca, Florence Cosca, Tiny Black, and Earl Nanninga. (Courtesy Loretta Cosca.)

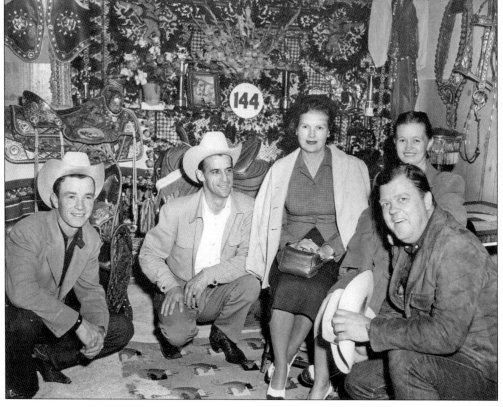

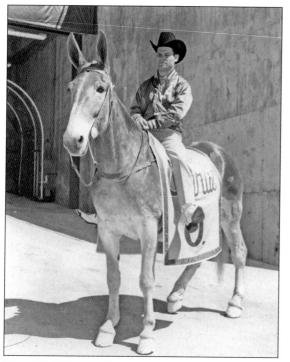

In the early 1970s, the most famous resident of Skyline Ranch was not the celebrated Stanley Cosca or the revered Jimmy or Tiny Black. Instead, it was the mule Charley O, mascot of the Oakland A's baseball team. At left, Steve Cosca is looking very relaxed aboard Charley O. In 1968, Charles Finley bought the Kansas City Athletics and moved them to Oakland. Soon the flamboyant Finley had introduced multicolored uniforms, players with facial hair, and orange baseballs. He contracted with Stanley Cosca for Charley O to be paraded around every home game, serenaded by the marching band, and mauled by excited children. (Courtesy Steve Cosca.)

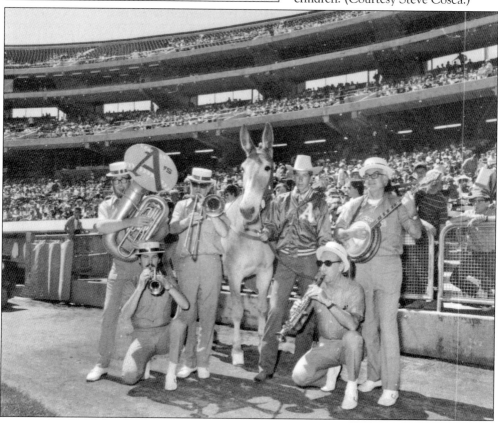

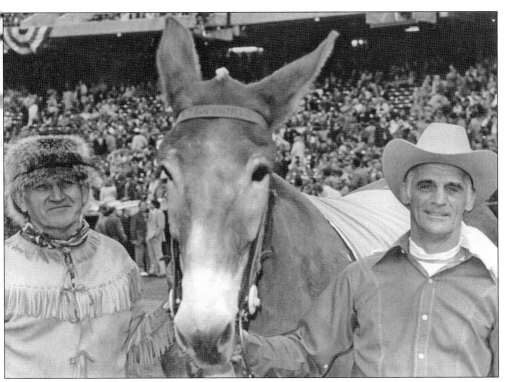

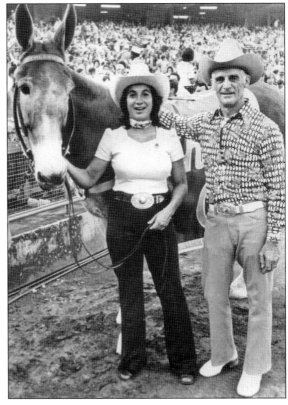

Harold Cummins reunites with his old Pinto Ranch partner, Stanley Cosca, as well as Charley O at an Oakland A's game in the 1970s. Harold is shown wearing the mountain man costume he wore to lead the Highway 50 Wagon Train, each year for over 20 years, as Wagon Master. After he left Oakland and moved to Sutter Creek, Harold was a longtime member of the Kit Carson Mountain Men Lodge in the Jackson area. (Courtesy Loretta Cosca.)

Cosca enlisted capable wranglers, including Alexis Paras Barba, shown here, to handle Charley O at the Coliseum—and for his occasional engagements in hotel lobbies. (Alexis is now a trainer at the Santa Anita Race Track in Southern California.) On his days off, Charley O was ridden from Skyline Ranch on the trails of upper Redwood Park by Scotty ("Bobby") Black, Joey Matthews, and others. (Courtesy Debbie Miller.)

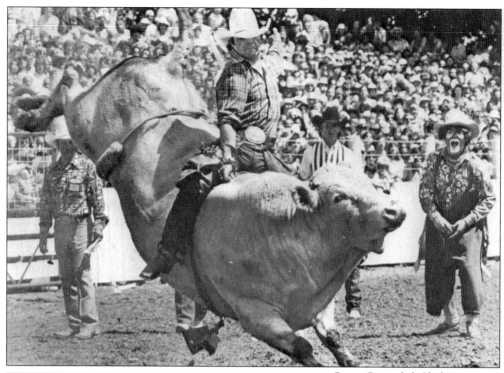

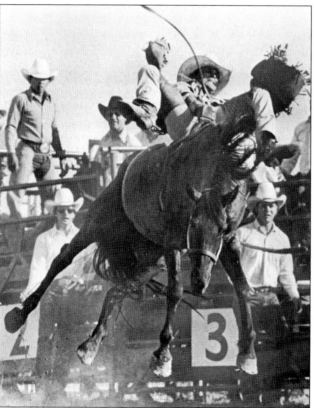

Steve Cosca left Skyline Ranch as a young man to pursue a rodeo career. In this photograph, Steve displays the talent (and luck) that won him the Professional Rodeo Cowboys Association title of Champion Bull Rider in 1973. This ride was in St. Paul, Oregon. Steve was a good friend of rodeo champion Larry Mahan, who often visited Skyline Ranch in the 1970s. (Courtesy Steve Cosca.)

This is a photograph of the ride that won Steve Cosca the title of the Professional Rodeo Cowboys Association Champion Bareback Bronc in 1979. The ride shown took place in Marysville, California. (Courtesy Steve Cosca.)

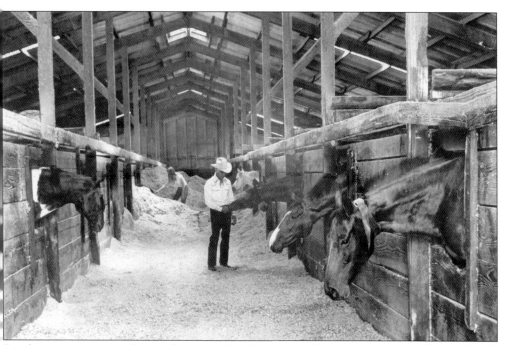

Stanley pauses to pet a favorite horse in this photograph taken in the barn at Skyline Ranch around 1976. The barn was designed so that trucks could drive right up to the end of the barn to unload. They used to keep a year's supply of hay in the aisle but later stored shavings there. (Courtesy Vivian Graham.)

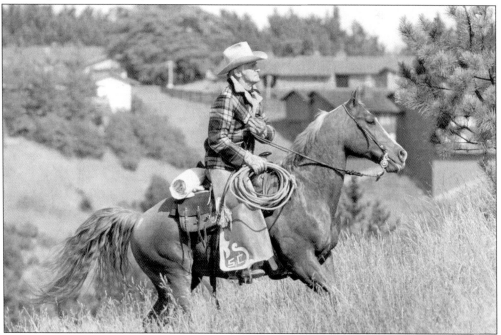

Stanley Cosca rides off into the sunset in the hills near Skyline Ranch on George Tesio's Quarter Horse stallion, Cannonball, in the 1970s. George owned Tesio's Meat Company. (Courtesy Vivian Graham.)

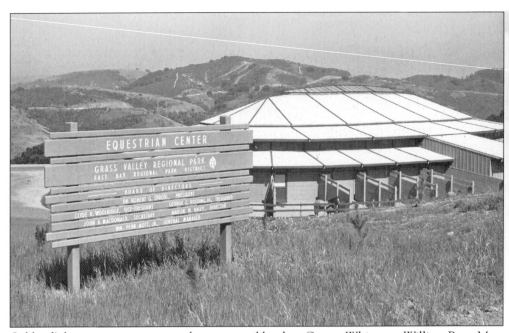

Oakland's largest equestrian center became possible when George White met William Penn Mott around 1963. Since 1959, George and Yvonne White had rented the Wagon Wheel Ranch from the pioneering Lincoln family. But with money to be made selling land for tract homes, the Wagon Wheel was being sacrificed. As general manager of the East Bay Regional Parks District from 1962 to 1967, Mott doubled the park area to over 20,000 acres. He had just acquired the open space that is now Anthony Chabot Regional Park from original ranchers, including the Marciel family. There was no budget to build an equestrian center. Appealing to Mott's mission for public access, George and Yvonne agreed to pay for the construction and thus became the operators. The layout was designed to resemble the shape of a turtle when viewed from above. (Courtesy EBRPD Archives.)

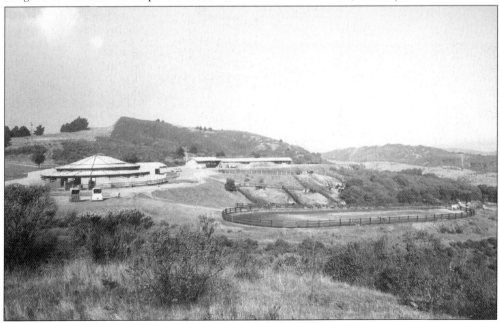

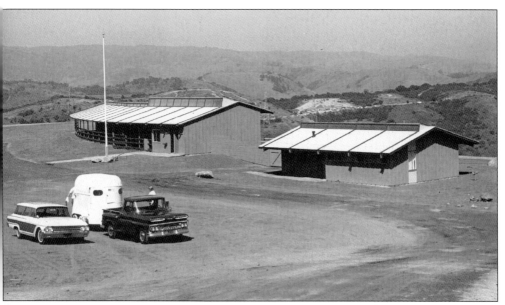

Anthony Chabot Equestrian Center initially consisted of a round barn for boarders' horses, a managers' residence, and a rent barn overlooking the majestic east view to the Grass Valley Trail. The construction labor was performed by convicts. When the buildings were completed, the convicts got a chance to ride in the arena. After George died, Yvonne continued to run the place, including a rent string, until 1990. In the early 1990s, longtime boarder and employee Sara Crary took over the management. The light area in the background is the site of the now-closed motorcycle hill climbs. (Courtesy EBRPD Archives.)

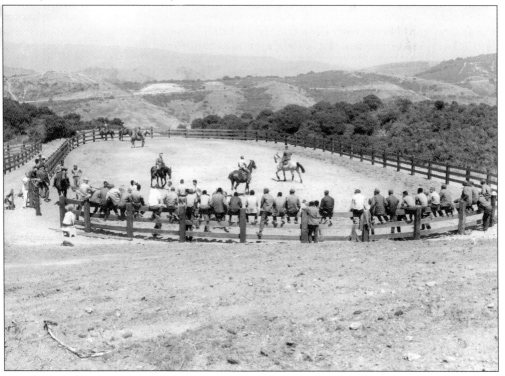

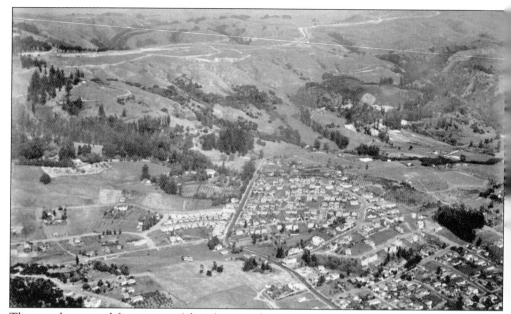

The aerial eastward-facing view (above), around 1935, shows the area south of Joaquin Miller Park. The new Avenue Terrace neighborhood, now called Redwood Heights, lies southeast of the junction of Redwood Road and Thirty-fifth Avenue. Old Redwood Road twists along the hillside above the quarry, right of center. Tiny Black would ride down from the Pinto Ranch to mom-and-pop stores in Avenue Terrace. Gus and Elsa Himmelman's house is at the far end of Redwood Road. At left, the McGhee mansion in the grove was replaced by the Holy Names University campus. Yvonne White recalls neighborhood kids calling it "the haunted house." The Devil's Punchbowl appears at the right edge of the image, halfway down the hill, amid the trees. A map (below) shows the new Redwood Regional Park. (Above, courtesy John Bosko, from the Milton Taylor estate; below, courtesy D. Rosario.)

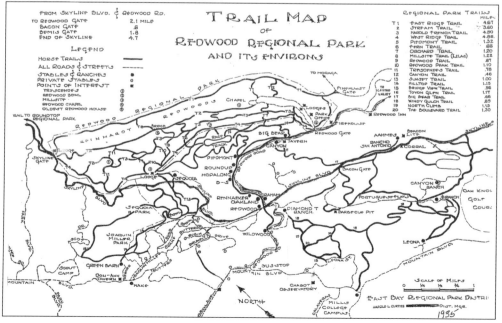

Two

THE CRESSMOUNT RIDING ACADEMY AT MILLS COLLEGE

Cornelia Van Ness Cress, third from the left, created a world-class equestrian program at Mills College between 1928 and 1954. Thousands learned to ride at Cressmount; not only Mills students, but youth from the surrounding communities as well. Orphans from the Fanny Wall, Defremery, and Lincoln Children's homes were guests at horse shows. Some received a first riding lesson. Olympic-level rider Chan Turnley went to Cress to learn to ride "properly." The magnitude of Cress's achievements stand as proof of her genius. By all accounts, she was a stern taskmistress. Yet those who knew her well recall that she always had the best interests of her students in mind. Standing in the grandstand box at the far left is Bob Lorimer. At the far right is Kay Tucker, who bought Cressmount upon the retirement of Cress in 1954. Erling Hansen identifies the rider as Sylvia Brooks. (All images in this chapter are courtesy of Chris Bearden and Mills College Library, from the estate of Mary Lou Reese.)

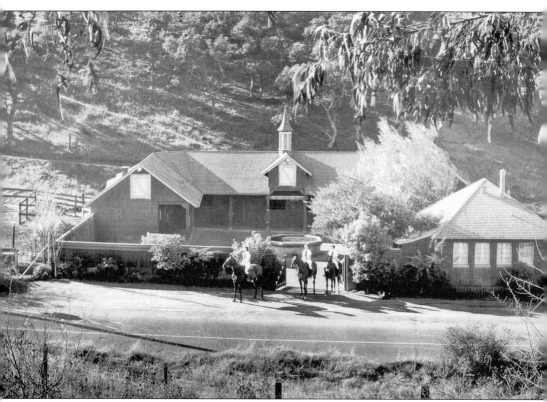

The Cressmount barn was built by Don D. Hayford ("The Montana Kid") around 1920. It was originally called Lake Aliso Riding Academy, at 5909 Mountain Boulevard. Erl Hansen started working there in 1924, as a boy of 12. In 1927, retired cavalry general George O. Cress bought the stable for his daughter Cornelia. The Cress family took up residence in Faculty Glen, where a peace pipe and feathered war bonnet on the mantelpiece were reputed to have been given to the general by Sitting Bull. Along with his brother Woodrow, Erl worked to improve the stable, constructing stalls, offices, and a residence in the building (right) and a hayloft (left). Later they built the jumps for the Upson Downs hunter course. Each week, workers drained and scrubbed out the octagonal horse trough in the stable courtyard. The site is now the Mills service yard and the Seminary Avenue off-ramp from Interstate Highway 580.

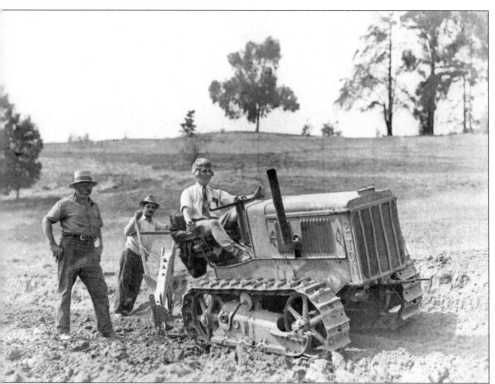

Cress took a hands-on approach to building her riding academy. In these images (from around 1928), ground has been broken for the new riding arena on Seminary Avenue near Mountain Boulevard. In the image above, looking north over Upson Downs, the tractor owner watched nervously as "a woman driver" handled his machine, according to Erl Hansen. Below, Cornelia Cress sits on the truck running board and Erl stands in the middle. The eucalyptus logs would become part of the jumps being built on Upson Downs. The hill shown at right appears to be the location of the present Millsmont neighborhood before houses were built. A short flight of concrete steps on Seminary Avenue is all that now remains of the grandstand.

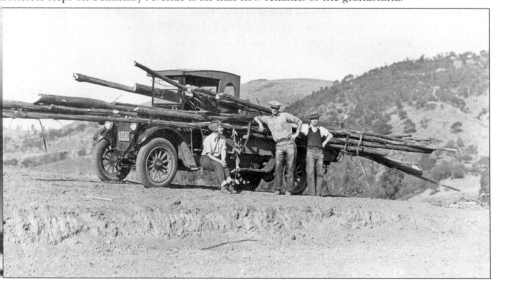

Looking south toward Seminary Avenue, the first riding arena is under construction. The hillside at left is open space owned by Mills College. A gas station can be seen at the left of the new arena. A two-story well house can be seen in the background at center left. By the mid-1960s, Interstate Highway 580 would become the dominant feature on the left and all the horse facilities would vanish.

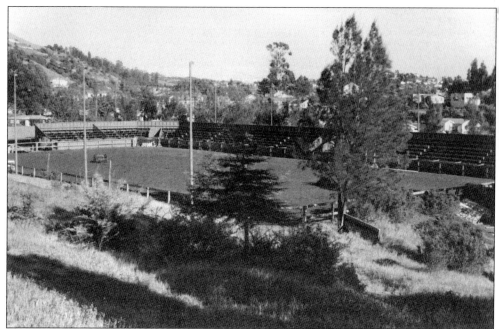

The Cressmount outdoor arena, when completed in 1933, seated 1,500 spectators. Booths were provided for dignitaries and special guests. Mountain Boulevard can be seen at the foot of the hill to the left of the arena. Seminary Avenue is behind the grandstand at the center and right of the image. Upson Downs is behind the photographer.

Mary Lou Hutton started riding at Cressmount as a young girl in the early 1930s after immigrating to Oakland from England. She progressed and excelled, becoming a top competitor and instructor. Her aunt was Aurelia Henry Reinhardt, legendary third president of Mills College from 1916 to 1943 and a great supporter of the Cressmount program. Later in life, Mary Lou Reese continued to teach generations of young people to ride. She was a beloved national leader in the U.S. Pony Club until her death in 2006 at the age of 80. Below, Mary Lou takes the chestnut Rum Punch over one of the jumps built by Erl Hansen.

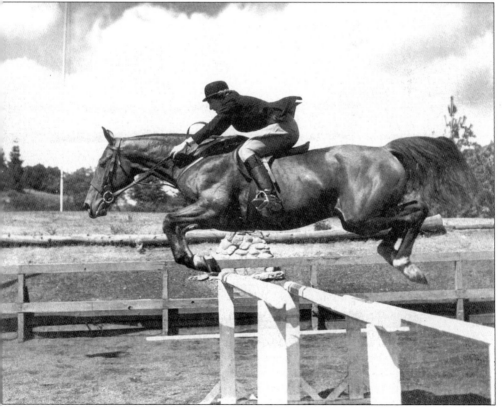

Cressmount riders younger than 12 joined the Pegasus Patrol. The youngest children joined the Junior Patrol as apprentices. Basic lessons and trail rides around campus led to increasing skill. Good behavior within the Pegasus Patrol was ensured by the custom of voting members in (or out) based on their sportsmanlike and agreeable attitude. Even with this kind of peer pressure, the patrol numbered about 100 strong in some years. Here Barbara Bechtel prepares to mount, with Sandy McKeen giving her a leg up and holding—an umbrella! The 11th Annual Junior Horse Show, held October 23, 1947, was a fund-raising event for the construction of a fine new indoor arena, east of the outdoor arena and south of the stable. The new arena was called "The Umbrella" because of the appearance of the open beams and rafters supporting the roof.

young adults joined the Bit and Spurs riding club at Cressmount. There they gained proficiency through lessons, practice, and trail riding. Bit and Spurs riders maintained neat attire, turned out in white jodhpurs, blouses, and neckties. Some must have had friends in high places, as Gov. James ("Sunny Jim") Rolph attended the First Annual Horse Show on April 23, 1932, as a Bit and Spurs guest, along with Mayor Fred Morcom and Lt. J. A. Geary from the Presidio of San Francisco. Above, the venerable Appaloosa Old Splash leads Bit and Spurs riders in formation from the stables to the riding ring around 1948. As the daughter of a U.S. cavalry general, Cornelia Cress required her students to follow military standards of discipline and technique as part of their basic training.

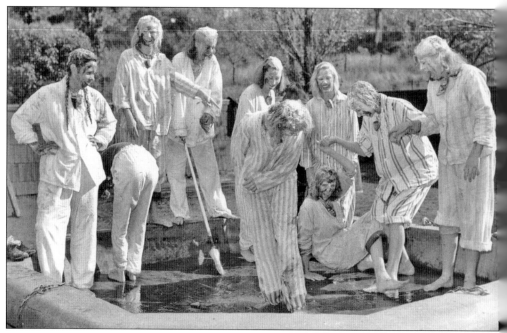

Only the most advanced riders could join the Shongehon drill team. The name (pronounced shon' gah hon) comes from the Blackfoot language meaning "leader of horses." It was bestowed by Cress, looking back on her father's days as a Rocky Mountain cavalryman and her own summer work as a wrangler in the Rocky Mountains. Above, 10 Cressmount women participate in a Shongehon initiation ceremony in the stable water trough, anointed with mud and clad in pajamas. Below, moving from the ridiculous to the sublime, the Shongehon color guard descends from Pine Top toward the Wetmore Gate with a reflecting pond fed by Leona Creek in the foreground. The Mills Children's School playground now stands in the area just right of the color guard. The pond remains.

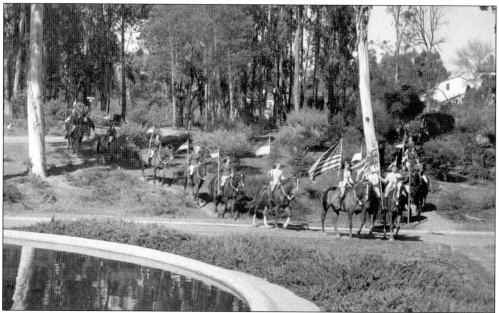

Cressmount horsewomen learned a wide range of skills. Here, from left to right, are Annabelle Gray, Elizabeth Harrison, and Virginia Hayden practice driving Lovely Lady. Standardbred harness horses were one of the many breeds found in the Cressmount stables.

Students prepare for a practice session in longeing and long-lining. The sparse number of houses in the background against the hills and the simple design of the horse arena suggest that this photograph was taken around 1930.

During World War II, Cress organized a mounted auxiliary to the Oakland Civil Defense Council, recruiting local residents as well as advanced Mills riders. Above, a *c.* 1943 team practices the evacuation of a victim with one arm in a sling. Note the triangular patch insignia on the women's left shoulders. Cress trained this civil defense force in scouting and patrols based on the principles of the U.S. Cavalry Manual. Mills women joined with a group from the Aahmes Shrine Rangers to patrol along Skyline Drive (now Boulevard), which was still unpaved south of Redwood Road. No enemy parachutes were reported coming over the Golden Gate. Mounted Patrol captain G. Earle Whitten wrote to Cress that 24-hour patrol of the hills would be stopped as of October 30, 1943. Shown below, from left to right, are Pat Gorie, Barbara Baup, Ann Powers, and Beverly Rosenthal.

The postwar years of 1945–1955 saw a huge resurgence in enthusiasm for the Mills College horse shows. Junior Horse Show judges, shown from left to right, were Woodrow Hansen, Lt. James Martin, and Col. R. S. Lovell. Note the crossed-swords cavalry insignia on Lieutenant Martin's lapel. Standing at right is announcer and ringmaster E. P. Peabody. Cavalrymen from the 143rd Field Artillery of the California National Guard, neighbors of Leona Stables, were avid participants.

Recuperating veterans from the U.S. Naval Hospital at Oak Knoll were guests of honor at the post–World War II Mills College horse shows. The pinnacle of showmanship came when Bob Lorimer made a chariot from a 55-gallon oil drum and, wearing a toga, drove a team around the arena to entertain the troops. Here a soldier awards a ribbon to a Western rider, with a sailor and a nurse looking on. Western events were a regular part of Mills horse shows.

Strict though she might have been, Cornelia Cress made sure that her young riders had fun. "She was always inventing original activities for them to do," Erl Hansen recalls. Sack races and mounted scavenger hunts provided variety from the discipline of horsemanship. Here a Halloween ride lends a surreal quality to an overcast autumn day.

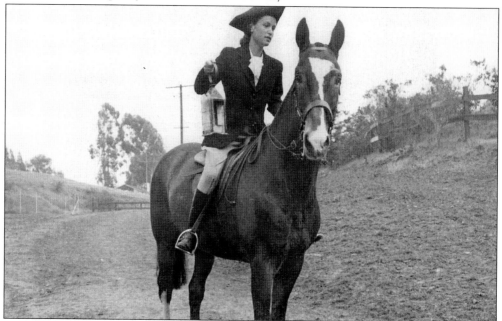

During the Cressmount era, horseback riding was an essential part of campus life at Mills. Here Lenore Rosenfeld of New York rides from dorm to dorm in a reenactment of Paul Revere's ride. She is announcing the upcoming performances of the Drama Association's production of *The Contrast* at the Mills concert hall. In addition to the residence halls, she visited the College Shop and administration buildings, crying out the news, "*The Contrast* is coming!"

Three

THE HORSE TRAINERS AND RIDING INSTRUCTORS

Beatrice Graham is remembered as a beloved horsewoman and instructor. For nearly half a century, she taught riders both young and old. Upon emigrating from England with her father, Richard, a professional coachman, Miss Graham set up her stable operations in a number of locations. In this image, she holds a horse by the barn at her second location in Redwood Canyon—close to the site of the Redwood Roundup tavern. She had previously operated at the site that was later to become Skyline Ranch. (Courtesy John Kirby.)

Riders from Miss Graham's Orinda Riding Academy rode together to the huge horse show put on by the Lafayette Horsemen's Association in 1936. The show was held on the old St. Mary's Road, near the intersection of Solana Drive. Hundreds of riders and thousands of spectators attended. The annual event was started in 1935 and was held in conjunction with the town-wide Fiesta.

From left to right are Lloyd Graham, four unidentified people, Pete Marron on Buckskin, an unidentified person, Leonard Phillips, Peggy Donaldson (Lloyd's sister), four unidentified people, Bill Rose (worked for Miss Graham), Don Donaldson (Lloyd's brother), and Miss Graham on the end. (Courtesy Lloyd Graham.)

This advertisement for Miss Graham's Riding Academy appeared in the *Observer* newspaper on October 26, 1912. At that time, dirt roads led down from the hills to the Riding Academy located at Twenty-fourth Street and Telegraph Avenue. It is interesting to note that despite the early date, Graham had a lighted indoor riding ring. (Courtesy Lloyd Graham.)

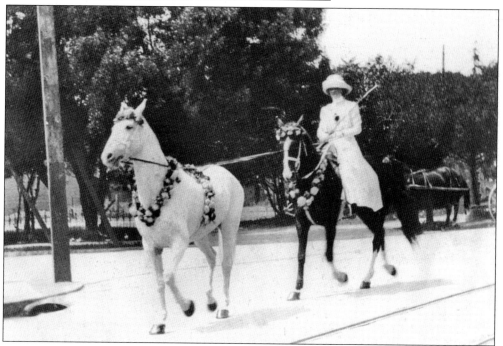

Miss Beatrice Graham, astride her horse in colorful floral arrangements, ponies (leads) another horse during a parade down Claremont Avenue in the 1920s. At the time this photograph was taken, Miss Graham's Riding Academy was located on Claremont Avenue near the intersection of Ashby Avenue. Instruction was offered for both riding and driving teams of horses, with special care given to children. (Courtesy Lloyd Graham.)

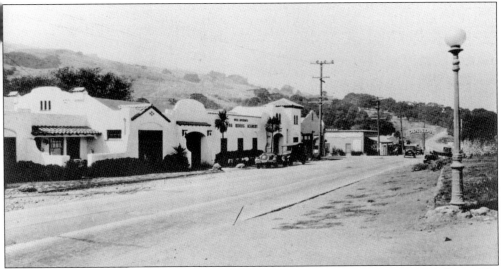

Miss Graham moved to Orinda in the late 1920s. She remained at this location until about 1938, when she returned to Oakland and settled into Redwood Canyon at the present site of Skyline Ranch. The car in the middle of the road, under the Orinda arch, is near the site of what is now Theatre Square. (Courtesy Lloyd Graham.)

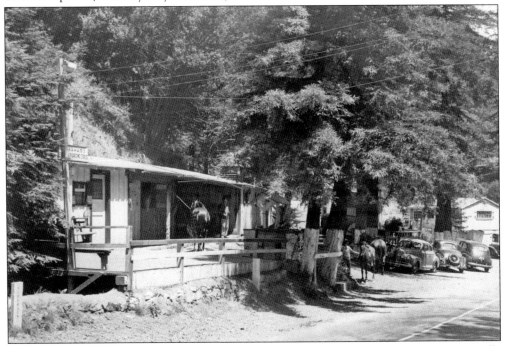

Miss Graham's riding stable in Redwood Canyon had no street address. The stable was originally called the B-S and was run by Tex Beneke. In 1946, at the time this photograph was taken, Redwood Road was a rural country lane. Today there is little evidence of this stable and the other structures shown, but the trees on Redwood Road still sport a coat of reflective white paint at eye level to deter collisions. Before the dedication of Redwood Regional Park around 1936, more than 50 homes stood in the canyon, along with a full complement of taverns and a bordello near the present park entrance. (Courtesy John Kirby.)

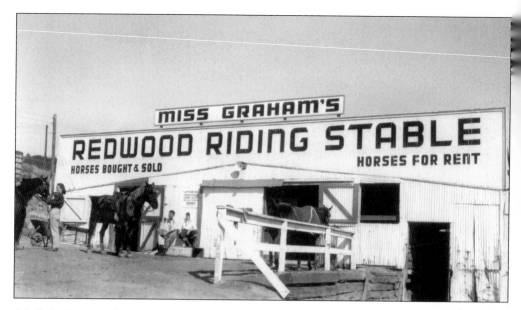

Of all the barns in the area, Miss Graham's Redwood Riding Stable commanded the finest views of Oakland and San Francisco Bay. It was at this location that her operation thrived until her death in 1951, turning out a regular crop of young riders for the MHA Juniors. Lloyd continued to operate the stable until it was torn down in 1953. Trails leading from Miss Graham's arena went for miles into the open parkland. The view below shows the present vicinity of Skyline Boulevard, Pembroke Court, and Redwood Road. Prior to the paving and development of the area in the 1960s, the stable street address was 3900 Joaquin Miller Road. Note Skyline Ranch in the background. No houses have been built yet on the hilltops south of Redwood Road or adjacent to what would become the Hunt Field. (Courtesy John Kirby.)

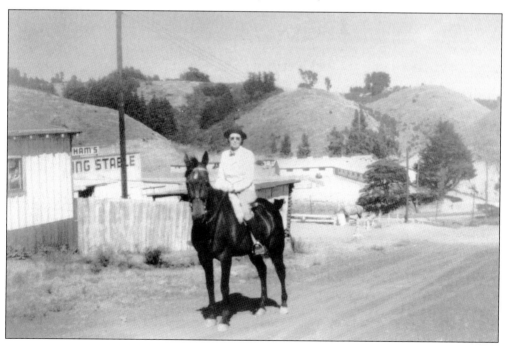

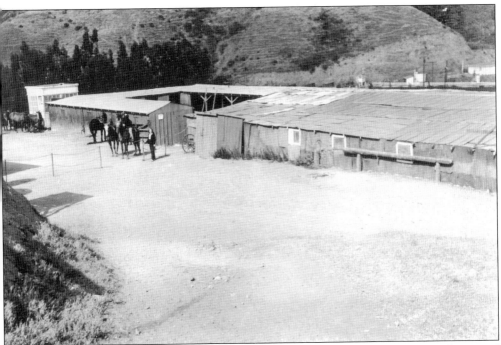

This rare view of the back of Miss Graham's Redwood Riding Stable shows many stalls. Part of Skyline Ranch is visible to the south over the barn roof. Behind the photographer, a water tank is sited at the top of the hill, into which Bob Lorimer pumped water from one of the springs in the porous serpentine rock hillside. (Courtesy John Kirby.)

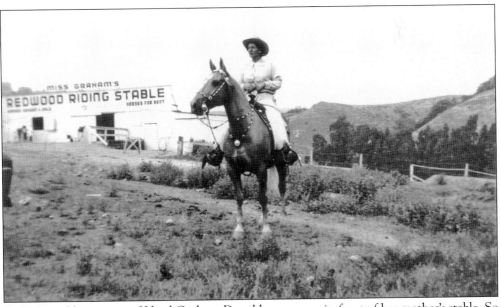

Peggy Donaldson, sister of Lloyd Graham Donaldson, pauses in front of her mother's stable. So great was Miss Graham's renown that her son is generally known by his mother's name rather than his father's. One of the most scenic high trails in Redwood Regional Park is named the Graham Trail in their honor. (Courtesy John Kirby.)

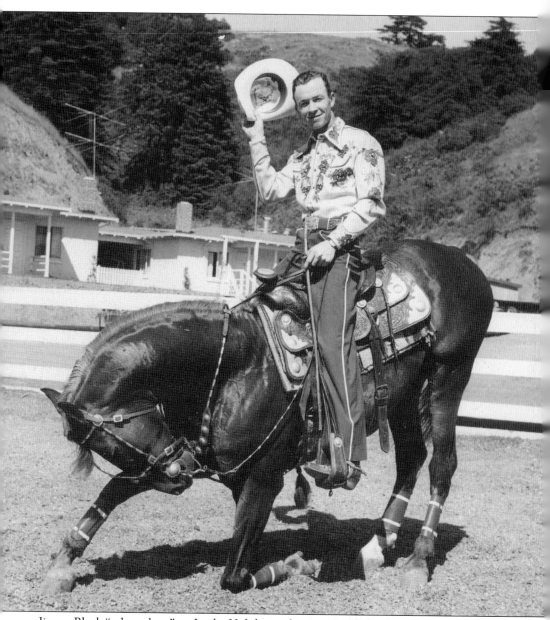

Jimmy Black "takes a bow" on Lucky Holiday, a chestnut Saddlebred stallion he was training for Mr. and Mrs. Claude Jones at Skyline Ranch. This 1950s photograph shows Jimmy and Lucky both decked out in the finest trappings of that time. Jimmy's colorful outfit was made by his wife, Tiny. His silver saddle was made by Rowell's Saddlery, and the horse bit is a popular Visalia Humane. (Courtesy Tiny Black.)

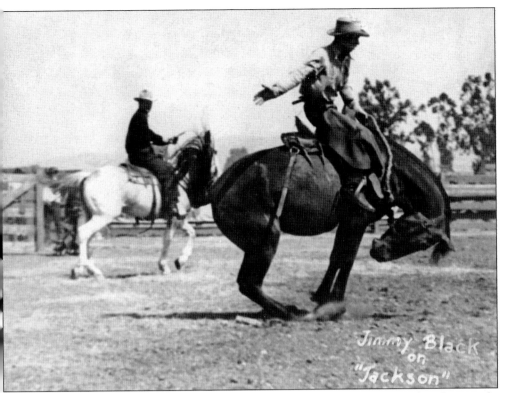

Before Jimmy Black became a horse trainer, he tried his hand at bronc riding. In this photograph, Jim is shown riding Jackson at the 1938 Livermore Rodeo. From 1936 to 1938, Jim rode bareback and saddle broncs in local rodeos. When his son Jim Black Jr. was born, his wife, Tiny, made him give up his rodeo days. (Courtesy Tiny Black.)

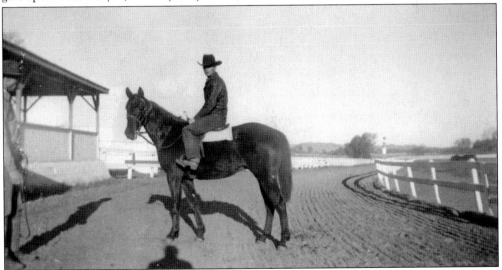

Around 1947, Jim Black got a job training racehorses at the Marchbanks Race Track in Walnut Creek. Jim and friend Mike Pascale broke Thoroughbred yearlings to race as two-year-olds and had to arrive each morning promptly at 5:00 a.m. to start their workouts. The Marchbanks track is now Heather Farms. (Courtesy Tiny Black.)

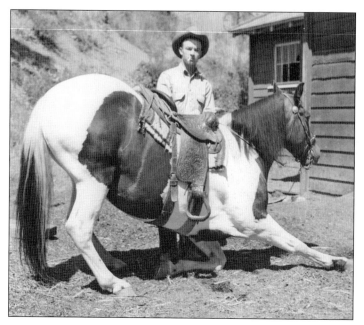

When Jim and Tiny Black moved to Piedmont Stables in the early 1940s, the stable was private. Jim partnered with Bill Patten to open the stable to public boarding. During World War II, a horse fell on Jim and broke his leg, and he was sent home as unfit to serve. Jim then went to work for Cutter Laboratories drawing blood from horses to make serum for the war effort. In this 1940s photograph, Jim is training Bobby to do tricks. (Courtesy Tiny Black.)

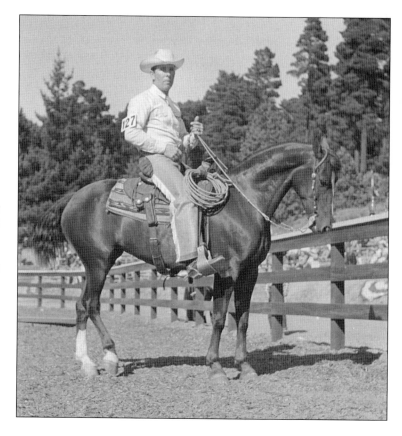

Walt Letham is shown riding Waspy B at a horse show at Sequoia Arena. Jim Black bought the Quarter Horse mare in 1947 and trained her to be a stock horse. Walt Letham bought her from Jim. Walt also built the Skyline Ranch, including homes for the Coscas and the Blacks. (Courtesy Loretta Cosca.)

Tiny Black is shown on Rabbit, a half Quarter Horse that Tiny and Jim bought when they were at the Pinto Ranch. They used him for roping. Later Tiny rode him in horse shows from the 1950s to 1960s. Rabbit hated riding in the trailer and once got himself completely turned around on a trip to the Cow Palace. When Tiny arrived, Rabbit was looking out the back door of the trailer! (Courtesy Tiny Black.)

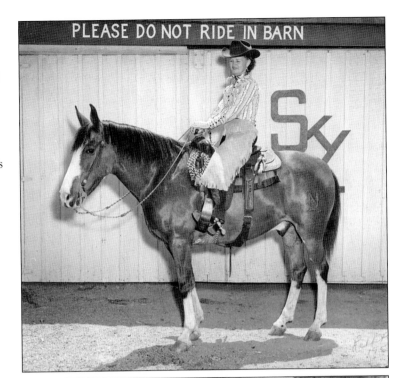

Shown are Jim Black and Bobby performing at Harry Rowell's Ranch Rodeo in the 1940s. The act was called Jim Black's Horse Act and was narrated by the announcer. The scene starts with Jim getting lost in the desert. He's in bad shape, and Bobby picks him up, flips him onto his back, and carries him to safety. Then Bobby would bow and dance and do a variety of tricks to delight the audience. (Courtesy Tiny Black.)

Jim and Tiny Black pause for a 1950s photograph of happy times in the riding ring at Skyline Ranch. Jim is riding Pistol Pete, and Tiny is riding Rabbit. Miss Graham's Redwood Riding Stable arena can be seen on the hill in the distance. (Courtesy Tiny Black.)

Tiny Black is shown riding Pistol Pete at a Sequoia Arena horse show around 1965. Pete was a Quarter Horse whose registered name was Publisher. Pete was the most well trained horse Jim and Tiny ever had. They bought him as a yearling, and Jim did all his training. (Courtesy Tiny Black.)

Jimmy Black trained Tuck for Stanley Cosca. In this photograph, Steve Cosca has Tuck sit for the camera. Tuck is wearing the roughout saddle that Earl Nanninga made for Steve. Tuck was perhaps the most popular horse at Skyline Ranch. He entertained kids with his tricks and was gentle enough to give rides on. Ethel Colbert took care of Tuck for Stanley for many years. Loretta Cosca used him for trick roping. (Courtesy Steve Cosca.)

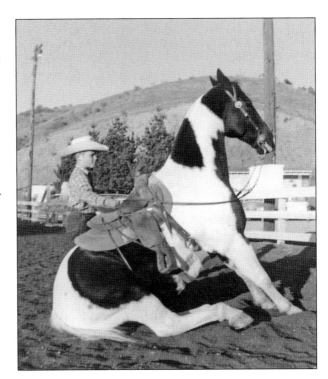

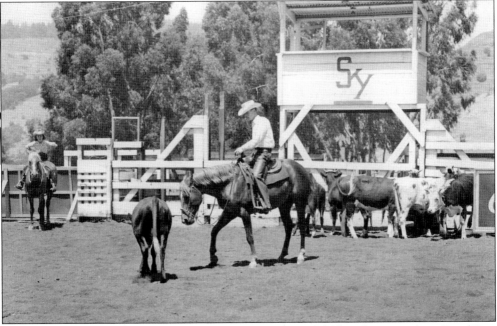

In this photograph, taken at Skyline Ranch in 1954, Jimmy Black is shown working Pistol Pete on a calf. Jimmy was known far and wide as an exceptionally "good hand" with horses. Though Jim is gone now, people still talk of his abilities with horses. A quiet and gentle man, he could easily be considered one of the original horse whisperers. (Courtesy Tiny Black.)

Jim Black Jr. ("Butch") is shown riding Rabbit at the Junior Grand National at the Cow Palace in 1959. The eldest son of Jim and Tiny Black, Butch won a pleasure class with over 30 horses. In the same class, Butch's younger brother Bill placed fifth riding Sammy. As children (while living at Skyline Ranch), the brothers attended school in the old brick building in Redwood Canyon, now the ranger station. In the 1970s, Butch had a tack shop at the Chabot Equestrian Center located in the current break room. (Courtesy Tiny Black.)

Tiny Black, riding Jody, is shown giving a riding lesson to then 10-year-old Terry Tobey riding Poco at the Skyline Ranch in December 1967. Tiny taught countless youngsters proper Western equitation over the years. Many of her students went on to win numerous awards because of her fine teaching. Tiny was, and still is, much beloved. (Courtesy Terry Tobey.)

Jimmy Black is pictured showing Flint Creek Blackhawk No. 110,857 at the Grand National Horse Show at the Cow Palace on October 25, 1971. The annual Appaloosa Day drew the finest Appaloosas from California and surrounding states, and with Jimmy's training, Blackhawk placed second in Two-Year-Old Geldings. Jimmy, an accredited horse-show judge, helped pick Blackhawk for Earl J. Tobey as a show horse for his daughter Terry. (Courtesy Terry Tobey.)

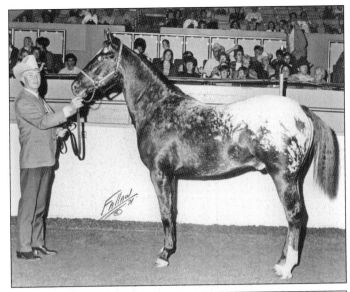

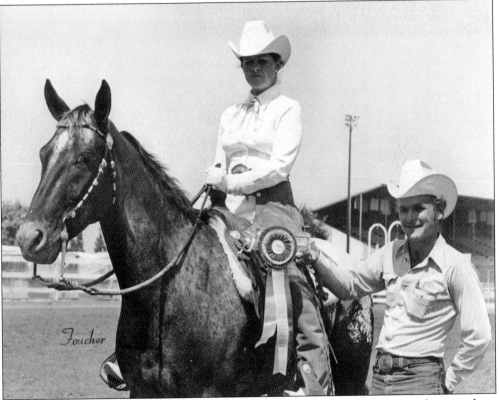

Trained in equitation as a child by Tiny Black, Terry Tobey went on to win numerous championships, high points, and year-end awards throughout California in the 1970s. Terry's Appaloosa, Flint Creek Blackhawk, was trained by Jimmy Black in stock-horse patterns (now called "reining") for Stock Seat Medal classes. Terry is shown winning an equitation class of 51 riders at the E Wa Tom Lih Kinh Appaloosa show in 1974. Terry was a member of the club and was chosen as their Appaloosa Queen that year. (Courtesy Terry Tobey.)

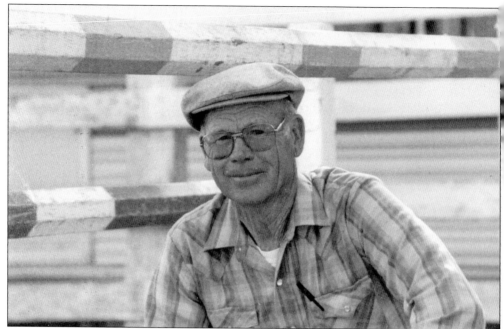

After 10 years working with Cornelia Cress at Mills College, Erl Hansen had become a skilled horseman and trainer in his own right. In 1939, he started a new career in the Chevron oil refinery. In World War II, he was drafted into the army, serving in North Africa and Italy. He returned to Chevron and was promoted to the research division. For the next half century, Erl provided regular "freelance" riding clinics in the evenings and on weekends. At first, he taught primarily in the MHA Sequoia Arena, as shown below. (The rider is Allison Stone on Penny.) In 1989, at the request of MHA officer Ed Hill, Erl began regular training sessions in the Hunt Field Arena above Lorimer's. The image above shows Erl at Skyline Ranch in 1988, at the age of 76. (Courtesy Erling Hansen and Leslie Wood.)

Four

THE LOCAL HANGOUTS

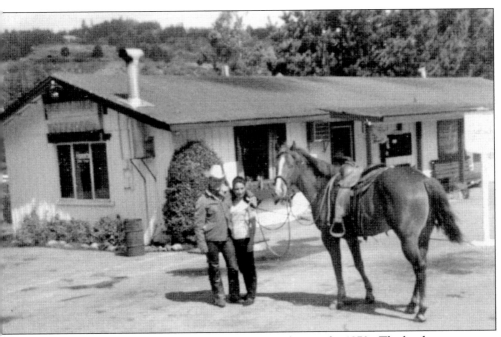

Steve Cosca poses with a friend outside the Skyline Kitchen in the 1970s. The kitchen was a very popular restaurant and meeting place for horse people in the area. The Coscas built it in 1949 as part of Skyline Ranch, and it was operated by Bert and Esther Gustafson for many years. After the park district bought the property in 1984, the kitchen was deemed out of compliance to the building code and was demolished. (Courtesy Steve Cosca.)

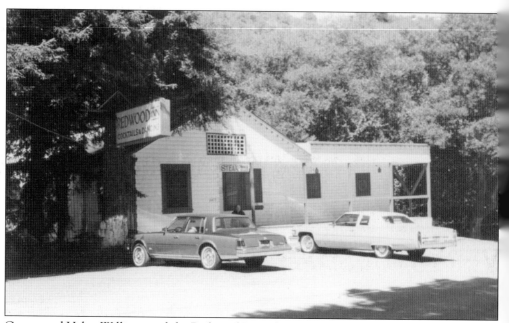

George and Helen Willis owned the Redwood Roundup from the 1940s until their son Don took it over when they retired. Don renamed it the Redwood Inn. It was built over the creek. Until the 1970s, it was not unusual to see horses tied out front while their owner stepped inside for a bite or some liquid refreshment. Lloyd Graham once rode a horse inside. Not to be outdone, his son Jeff once rode his motorcycle inside. Roger Hicks rode his Honda 450 in and circled the dance floor. It was a wild and crazy time! The unique redwood bar was made from trees that were harvested from where the building stood. The stone fireplace was built by pioneer rancher John Reis. The building was demolished in 1995. People still miss it. (Courtesy Roger Hicks.)

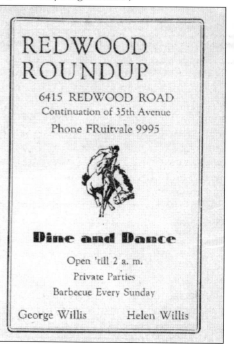

THE BIG BEAR

DANCE EVERY NIGHT

SQUARE DANCING
EVERY TUESDAY NIGHT

Under the Beautiful Redwoods
HUGH LEJEAL, Prop.

KEllog 2-9990 Oakland, California
7300 REDWOOD RD. - Cont. of 35th Ave.
(Member of MHA)

The Big Bear Tavern and stables was owned by Hugh Legeal, but he went by the name of "Lucky." Each fall during the Cow Palace, cowboys who were competing would come to the canyon to see Lucky at his "Oakie Stomp" as the tavern was then known. The Big Bear had live music and a stone fireplace so big that a person could walk into it. There were lots of fights, and customers frequently drank too much. One regular had a full-grown African lion that he brought inside. One night around 1960, the Hell's Angels rode up and tried to take over the bar. The fight was on. The cowboys got their ropes, saddled their horses, and went after the Angels. They roped the Angels off their bikes as they drove by. Lucky used a bullwhip to grab the spokes of the bikes and pull them out from under their riders. Unfortunately, Lucky and his wife were big-time gamblers. In the late 1960s, they got behind on their taxes and the park took back the tavern and immediately bulldozed it. It was the end of an era. (Courtesy MHA Archives.)

don & ann

"The Gateway to the Hills"

* * * *

SPECIAL DINNERS $1.45

Barbecued Spare Ribs or Half Fried Chicken. Salad, Soup, Coffee, Ice Cream

* * * *

SPECIAL FILET MIGNON STEAK DINNER $2.25

Salad, Soup, Coffee, Ice Cream

* * * *

COCKTAILS

2820 Mountain Blvd. KE. 2-9928

(Member of MHA)

Don and Ann's steak house, originally owned by Chris Hansen, served for decades as the favorite watering hole of MHA riders. Later Chris's son Jerry took it over. As it was located strategically at the foot of Joaquin Miller Park, riders could come from miles around, tie their horses, and dine. Before city construction crept up the hill, the only refreshment in the area was a snack bar known as the Hiker's Rest (owned by Lou Robinson). Don and Ann's, originally named the Mission Inn, was next door. By the 1940s, however, Don and Ann's was *the* place to get a good meal. Though the restaurant has been retooled for other cuisines in recent years, the interior decor still has open beams and Western touches. (Courtesy MHA Archives.)

Five

THE SADDLEMAKERS AND SILVERSMITHS

H. W. STARR

"THE SADDLE SHOP"

- SADDLES
- HARNESS

New & Used

REPAIRING AT REASONABLE PRICES

530 BROADWAY

Oakland, California

In 1911, Charles Starr bought Lemon Saddlery and with eight employees made and repaired saddles and harnesses for carts. Back then, horses still pulled carts to deliver milk and laundry and even pick up garbage. Charles's son, H. W. Starr, bought the business in 1937 and made fabulous silver saddles in the 1940s and 1950s. Before the shop closed in the early 1960s, it was owned by Dale and Bette Yearian. (Courtesy MHA Archives.)

Don Bentley and Dave Silva were partners in a saddle shop at the Pinto Ranch in the 1940s. Later Don owned the shop on his own. Both men previously worked for Rowell's Saddle Shop. Don was taught the art of saddlemaking by Art Vancore. When the Pinto Ranch was demolished in 1959, Don moved his shop to MacArthur Boulevard, Diablo, Pleasanton, and finally to Grass Valley. There he worked for Visalia Saddle Company along with owner Bill Majors and manager Jim Black Jr. (Courtesy MHA Archives.)

This saddle, seen around 1977, is one of the last Don Bentley ever made. Even at the end of his life, when he was with Visalia Stock Saddle Company in Grass Valley, his workmanship remained superb. Don was famous for his inlaid seats, fine buckstitching, and top-quality materials. Don made his first stamping tools from horseshoe nails. Though he could certainly carve leather, Don let Frank Franta tool this beauty. Don was also famous for developing his original liquid glycerine saddle and leather conditioner, the first batches of which were made in his bathtub. It is such a good product that it continues to be sold today, more than 40 years later. Before Don became a full-time saddlemaker, he was a butcher at Stanley's Market, owned by his friend Stan Cosca. (Courtesy Jim Black Jr.)

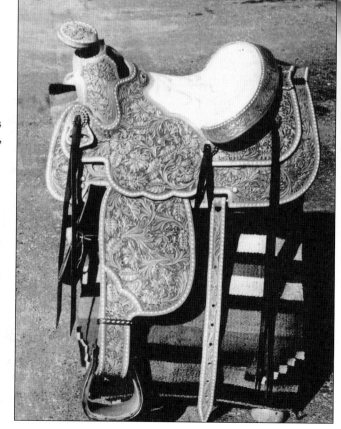

Earl Nanninga, on the far left, jokes with four-year-old Steve Cosca while two friends look on. The photograph was taken inside Earl's Saddle Shop at Skyline Ranch in 1954. Earl had shops in Walnut Creek and later on Mountain Boulevard before coming to Skyline in 1949. He remained at Skyline until approximately 1970. Later he moved to Clements, where he continued making saddles for the rest of his life. (Courtesy Steve Cosca.)

In this 1954 photograph, Steve Cosca is shown trying out the saddle that his good friend Earl Nanninga made especially for him for a Christmas present. The saddle was kid-sized but made to fit a full-grown horse. It was made of roughout leather; Steve still has the saddle today. Earl was known for making the most comfortable saddles and had a very devoted clientele. (Courtesy Steve Cosca.)

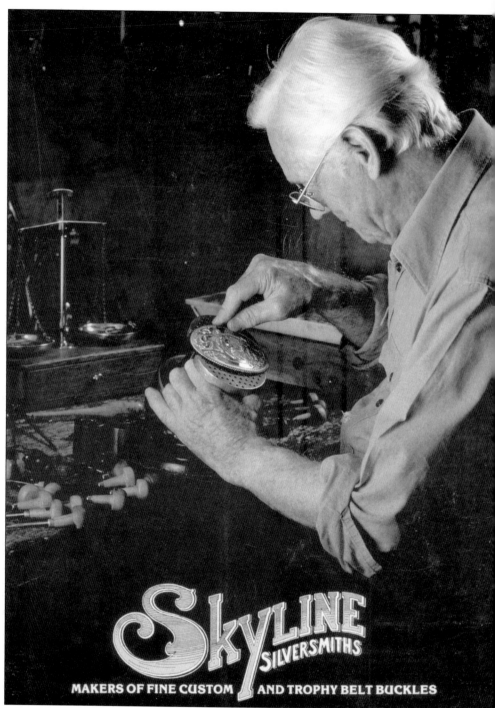

Jeff and Vivian Graham asked Earl J. Tobey to serve as the model for their Skyline Silversmiths catalog in 1980. Earl himself made jewelry for years at the Studio One art center in Oakland. Skyline Silversmiths did a brisk business in trophy belt buckles and similar finery. Jeff was originally a partner in the shop with Gary Gist until Gary left to start his own business, Gist Silversmiths. (Courtesy Vivian Troxell Graham.)

Six

THE TRICK RIDERS AND TRICK ROPERS

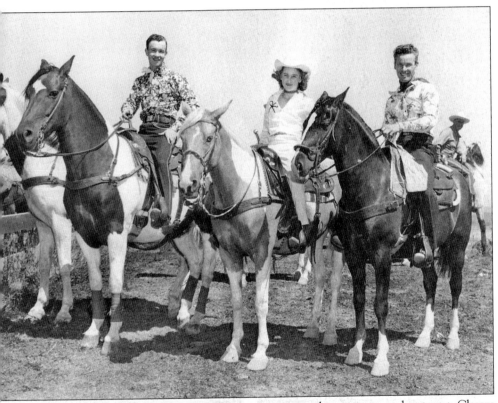

In the 1940s and 1950s, trick riding was a huge attraction at almost every cowboy event. Classes were held, and the winners received prizes. The riders galloped by, one by one, showing off their best tricks; seen here are three of the most popular. The trick riders from Skyline Ranch are, from left to right, Jimmy Black on Bobby, Loretta Cosca on Poppy, and Scotty Black on Buddy. Harry Rowell got the trio contracts to perform at Rodeo Cowboys Association (RCA) rodeos where he ran the bucking stock. (Courtesy Tiny Black.)

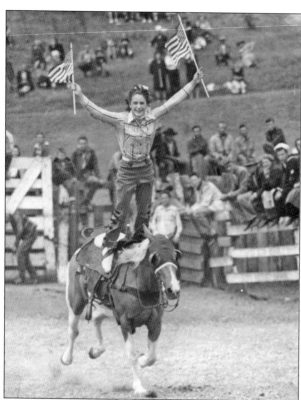

Loretta Cosca shows off her patriotism by performing a hippodrome stand at Harry Rowell's Ranch Rodeo in 1941. Loretta is riding her mare, Poppy. (Courtesy Loretta Cosca.)

Loretta Cosca performs what is called a Russian or suicide drag. Loretta is riding Poppy at the Shrine Rangers arena on Skyline Boulevard. Today the stable is owned by the City of Oakland and named City Stables. (Courtesy Loretta Cosca.)

This 1940s photograph, taken at the Shrine Rangers arena, shows Loretta Cosca trick roping. The trick is called the big loop and takes a great deal of strength because the rope is very heavy. Loretta is riding Poppy. (Courtesy Loretta Cosca.)

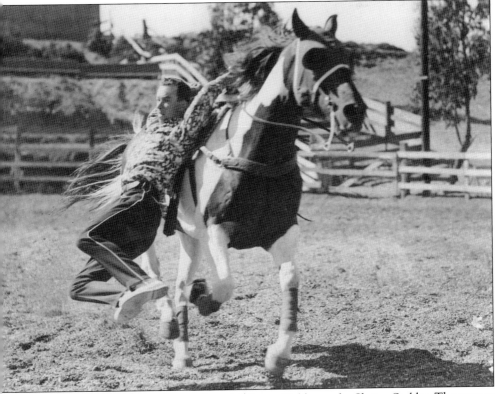

Jimmy Black performs a reverse drag on his trick horse, Bobby, at the Shrine Stables. The reverse drag was a trick that was only performed by men because of the upper body strength it required. This photograph was taken in October 1947. (Courtesy Tiny Black.)

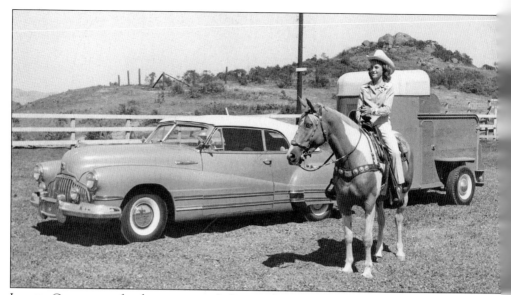

Loretta Cosca poses for the camera with Poppy after a performance at the Shrine Stables on September 8, 1947. The car, a Buick, had plenty of power to pull the single-axle trailer. (Courtesy Loretta Cosca.)

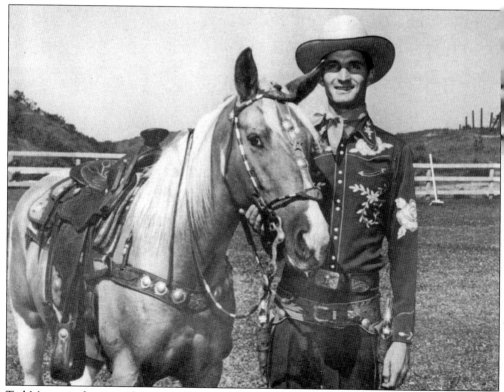

Tod Mason is shown with Loretta Cosca's mare, Poppy, at the Shrine Stable in the 1940s. Tod trained Poppy for tricks and taught Loretta to trick rope. Tod traveled all over to train and perform. When he came to Oakland, he stayed with Gus and Elsa Himmelman. Tod's specialties were trick roping, bullwhips, gun twirling, and guitar playing. (Courtesy Loretta Cosca.)

Loretta Cosca, riding Poppy, poses for a photograph with the world-famous Monte Montana. Loretta performed with Monte at the Livermore Rodeo, where this picture was taken in the 1940s. (Courtesy Loretta Cosca.)

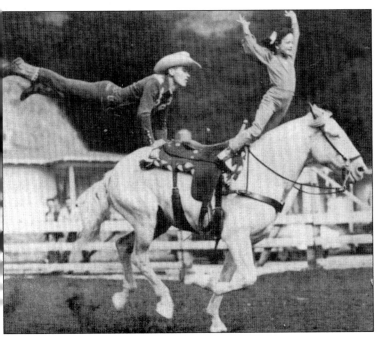

Scotty and Sandy Black, a trick-riding, father-and-daughter duo, perform a tandem trick on their horse, Eggshell. Scotty, shown hanging off the back, is performing a straight crouper while Sandy, in the front, is doing a hippodrome stand. The duo performed all over at rodeos and horse shows and was always a very welcome attraction. (Courtesy Loretta Cosca.)

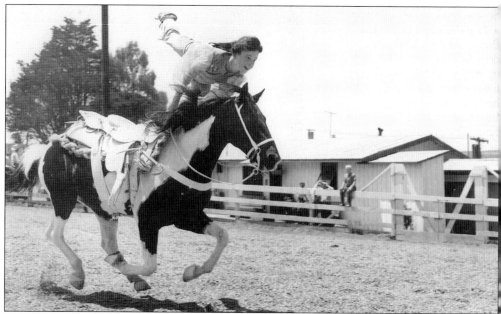

Sandy Black, daughter of Scotty and Margo Black, performs a one-foot stand on her pony, Trojan. The photograph was taken at the Skyline Ranch in the 1950s. (Courtesy Loretta Cosca.)

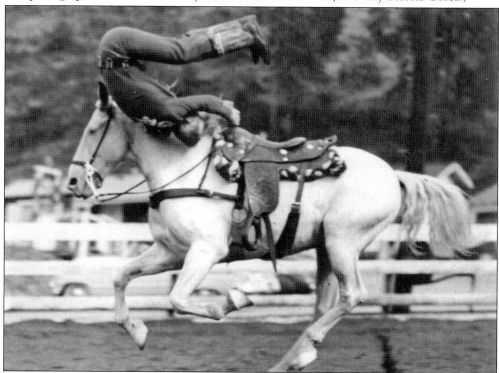

Scotty Black performs a front somersault on his horse, Eggshell, at the Skyline Ranch in the 1950s. This spectacular stunt is accomplished by standing up in the saddle while the horse is running at a full gallop (approximately 38 miles per hour), diving forward into a front somersault, turning completely upside down, then landing back in the saddle. (Courtesy Loretta Cosca.)

Scotty Black grins as he performs a shoulder stand on his horse, Buddy. The shoulder stand is done by first jumping straight up in the saddle, then diving forward and grasping the saddle horn and mane of the horse as he travels at 35 to 38 miles per hour. The photograph was taken at Miss Graham's Redwood Riding Stables in the 1940s. (Courtesy Loretta Cosca.)

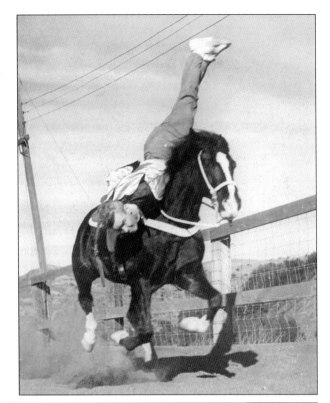

Scotty Black performs a side drag on his trick horse, Buddy. The photograph was taken at Miss Graham's Redwood Riding Stables in the 1940s. (Courtesy Loretta Cosca.)

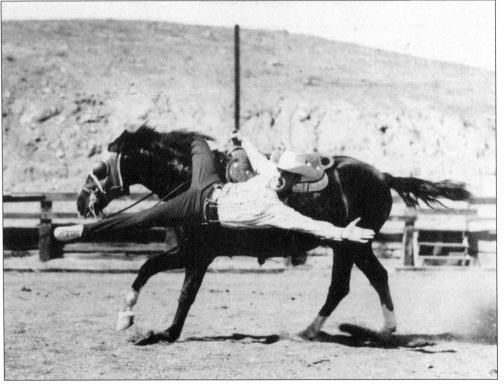

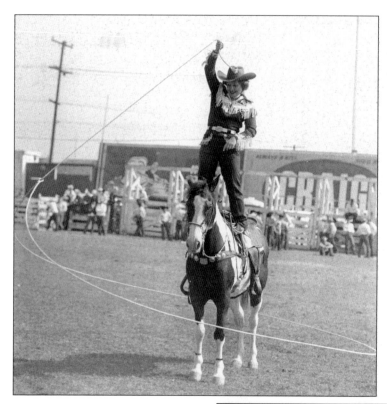

Loretta Cosca performs a big loop around her horse, Jeepers. This photograph was taken at the Emeryville Oaks ballpark arena in the 1950s. (Courtesy Loretta Cosca.)

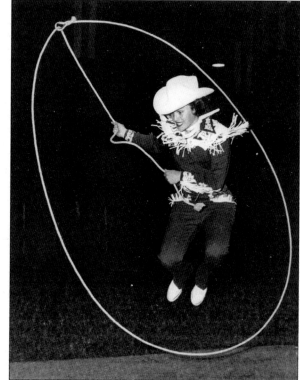

During an evening performance, Loretta Cosca is shown jumping through a big loop in the 1950s. Loretta had to tape her right index finger before every performance or the heat of the rope would burn her. (Courtesy Loretta Cosca.)

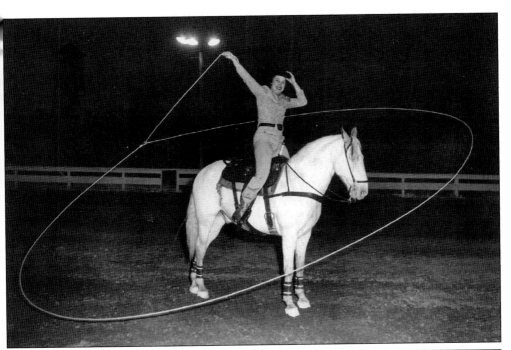

Loretta Cosca is shown performing a big loop on Scotty Black's horse, Eggshell. This 1950s photograph was taken in the evening at her family's Skyline Ranch. (Courtesy Loretta Cosca.)

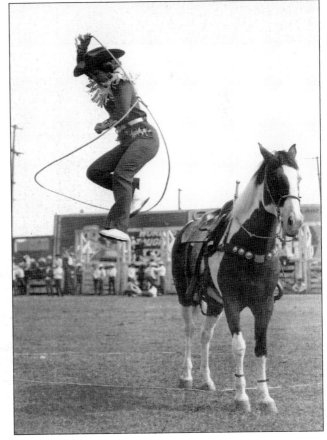

Loretta Cosca is shown performing a very dangerous trick. She made a flat loop and then jumped through it and off her horse, Jeepers. "The landing is very dangerous because you have to land flat and absorb the landing or you can shatter your foot, ankle, or leg," Loretta explained. This photograph was taken at the Emeryville Oaks ballpark in the 1950s. (Courtesy Loretta Cosca.)

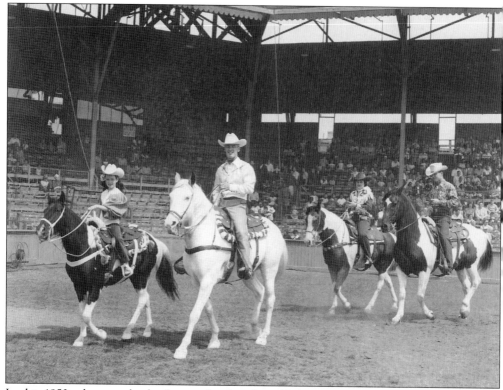

In this 1950s photograph, the four trick riders from Skyline Ranch are coming into the arena before a performance. From left to right are Sandy Black on Trojan, Scotty Black on Eggshell, Loretta Cosca on Jeepers, and Jimmy Black on Bobby. (Courtesy Loretta Cosca.)

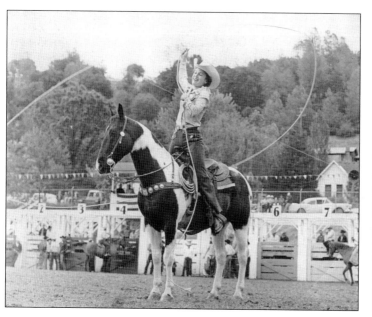

Loretta Cosca performs a big loop on her Dad's horse, Tuck. Tuck was originally purchased from Ivan Studley at Leona Stables. This photograph was taken in Sonora on Mother's Day in 1958. This was Loretta's last professional performance. (Courtesy Loretta Cosca.)

Seven

THE SPECIAL EVENTS

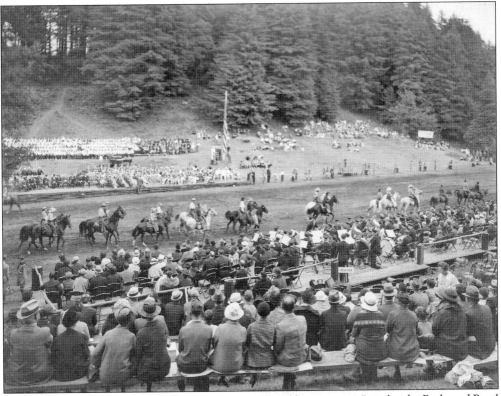

According to park district archives, "A cavalcade of local horse owners" circles the Redwood Bowl on October 18, 1936, in the inauguration ceremony for the East Bay Regional Parks District. The district started with three parks—Tilden, Sibley-Round Top, and Lake Temescal—and Redwood Regional Park soon followed. Charles Lee Tilden reportedly paid out of his own pocket for 60 acres of prime Oakland hilltop land, including the Redwood Bowl. Redwood Regional Park was officially designated in 1939. (Courtesy EBRPD Archives.)

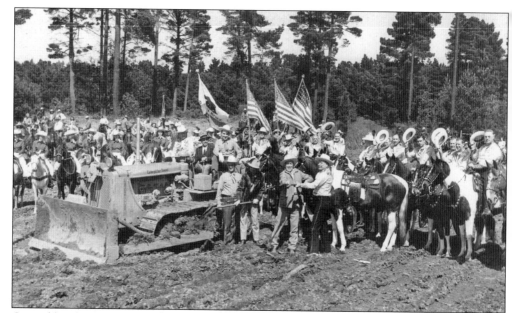

Ground-breaking day for the Sequoia Arena in Joaquin Miller Park was March 20, 1948. Dignitaries included Oakland parks superintendent William Penn Mott and the venerable Sydney Chown. With hills and trees resplendent with spring color, riders from the Aahmes Shrine Rangers, the Lari-ettes, and the Alameda County Sheriff's Posse joined the MHA to celebrate the new riding center. (Courtesy Oakland Public Library.)

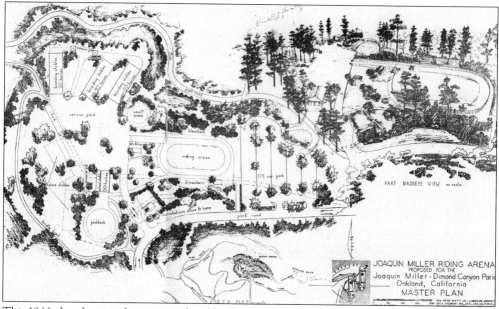

This 1946 plan drawing, by renowned parkland preservationist William Penn Mott, shows the scale of the postwar horse people's dream in an era when MHA shows drew thousands of spectators. William Penn Mott rose to distinction during his 17 years as Oakland superintendent of parks, a high point being his creation of Children's Fairyland. Mott collaborated with the MHA to build the Sequoia Arena as a first step toward transforming Joaquin Miller Park into a horseman's paradise. (Courtesy MHA Archives.)

On May 24, 1953, the EBRPD, along with the MHA, cosponsored the Grass Valley Opening Fiesta to celebrate the recent purchase of 3,000 acres of land by the park department from the East Bay Municipal Utility District (EBMUD). People gathered to ride 5 miles on the new Grass Valley Trail led by trails chairman and Oakland Mounted Police officer Jim Kecy. More than 200 riders arrived for the Grand Entry and dedication. (Courtesy MHA Archives.)

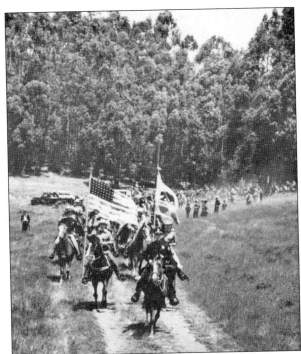

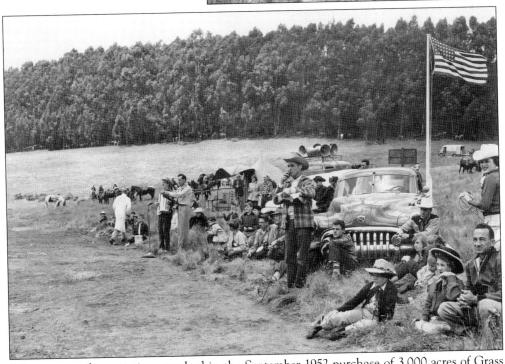

Fifteen years of negotiations resulted in the September 1952 purchase of 3,000 acres of Grass Valley land, making the 8,000-acre park one of the largest metropolitan parks in the country. Instrumental in the purchase was Richard Walpole, the board of directors of the EBRPD, and Howard G. Robinson, MHA past president and ardent equestrian supporter. The Opening Fiesta is shown in this May 24, 1953, photograph. (Courtesy Loretta Cosca.)

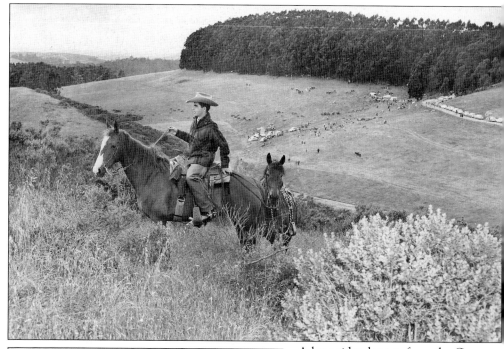

A lone rider departs from the Grass Valley opening festivities, which are shown in the distance. During the day, pony express rider Don Dreyer dashed by the crowd being pursued by "injuns." Boots and Jeans members square danced on horseback. Sandy Black sang and did trick riding with Jimmy and Scotty Black. Loretta Cosca performed trick roping, and Walter Leatham performed with his top stock horse, Waspy B. A good time was had by all. (Courtesy EBRPD Archives.)

On May 10, 1948, a Trail Ride and Field Day was held at Portuguese Flat. Some 230 riders gathered for a two-hour trail ride that took in the Sunset and French Trails. After lunch and awards for the ride, a play day was held. Events held at the "old race track" included several races as shown. (Courtesy MHA Archives.)

Bob and Lorraine Lorimer envisioned an open field where riders could school their steeds over fences, as in England itself. The Lorimers matched funds with the park district, and on 35 acres above the Oakland Riding Academy, the Hunt Field was constructed. The dedication day was March 14, 1964. Pink-coated riders of the Los Altos Hunt were the stars of the event, along with their hounds. Bishop Floyd L. Begin gave the invocation. Dignitaries gave speeches. The trumpet sounded and the bagpipes skirled. The Piedmont High School band played. Air Force colonel H. L. Poliski performed a dressage demonstration on his Lippizzaner stallion, Maestoso Pluto Conversono. The Lorimer daughters rode their ponies. (Courtesy EBRPD Archives.)

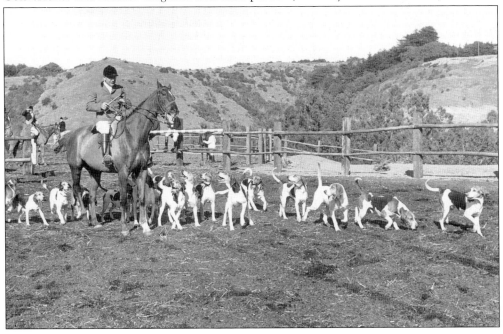

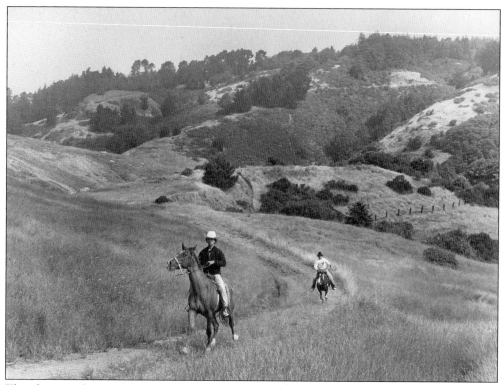

This photograph was taken in the 1960s before rare plants such as the endangered *presidium clarkia* daisy were identified in the Hunt Field, and the equestrian community was asked to remove the jumps in the early 1990s. Horses were soon outnumbered by off-leash dogs on the grassy slopes of the newly named Serpentine Prairie area. Still, the Hunt Field arena is in use on a daily basis, and the trails through the park open space are largely unchanged from the days when Miss Graham escorted her students through the area. (Courtesy EBRPD Archives.)

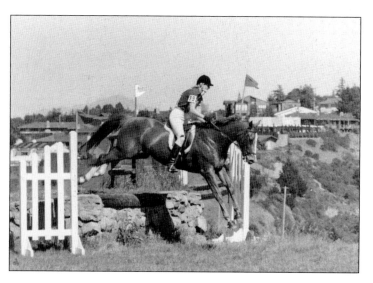

With MHA riders benefiting from training with Erl Hansen and other notable instructors, the Hunt Field was used for hunter trials throughout the 1970s. Here Kay Hitch is shown riding her horse, Master Charge, during the Hunter Trials in 1977. This view looks southeast across Redwood Road towards Balmoral Drive. (Courtesy Leslie Wood.)

Eight

THE GALLERY
OF HORSE PEOPLE

Sydney V. Chown, shown on his horse Guy Diablo, stands beside the statue of his friend Joaquin Miller in this c. 1949 photograph. Sydney, born in the late 1800s, worked his entire life for the betterment of equestrians in the Oakland Hills and was responsible for building many of the most popular trails. One of the original organizers of the Piedmont Trail Club, Sydney joined the MHA shortly after its 1938 founding and served as its 1952 president and Permanent Trails chairman. Sydney was the 1954 recipient of the MHA's highest award, the East Bay Regional Park District President's Cup, for outstanding contribution to horseback riding in the East Bay. After his death, MHA honored him in 1958 by holding an annual trail ride in his name. Sydney also owned Chown's Market at 1440 Leimert Boulevard, now known as Rocky's Market. (Courtesy MHA Archives.)

Pioneer horseman Art Denton was one of those who blazed the trails in the Oakland hills on what is now parkland and preserved open space. A street in the Skyline Boulevard corridor is named in his honor. Here he is shown with his mount that is carrying a Santa Barbara bit. (Courtesy MHA Archives.)

Claud Brandon, born in 1890, is shown riding his horse, Calico Pete, in July 1963. When he retired in 1952, he bought Pete and began riding the trails on an almost daily basis, returning home late in the day to Skyline Ranch. In 1967, after Claud's death, the MHA started a competitive trail ride and play day in his name as a way to honor their dear friend. (Courtesy MHA Archives.)

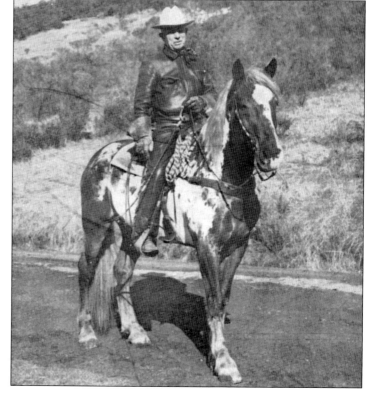

In this 1948 photograph, Heber J. Brown is shown on his favorite mount, his Pinto stallion Phlagg. Heber and his family all rode. They stabled their horses at their own barn near Lake Temescal. Heber was a lawyer who headed his own firm—Brown, Smith, and Ferguson. He was the 1950 president of MHA and an Aahmes Shrine Ranger. (Courtesy MHA Archives.)

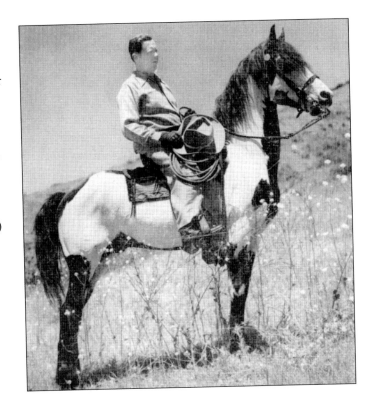

Gus and Elsa Himmelman, along with young Conrad Haas, present a trophy, with the Aahmes Shrine Rangers looking on, at the Sequoia Arena in 1963. Gus is remembered as a quiet man with a great sense of humor. In addition to providing the MHA with a clubhouse and running the social scene throughout the 1940s and 1950s, Gus was the liaison between the equestrian community and civic leaders. (Courtesy Conrad Haas.)

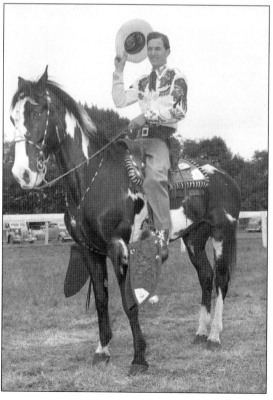

Country and Western singer Dude Martin reportedly built the Pinto Ranch but did not live there for long. According to Ted Johnson of Walnut Creek, shown above with his accordion, Dude has not been seen in these parts since he headed for the bright lights of Hollywood in 1954. Dude's music has experienced a recent revival in Europe. (Courtesy John Bosko.)

MHA leadership marks the changing of the guard in January 1949. Ted Dreyer, of the Aahmes Shrine Rangers and 1948 president, is on the left. Jim Myers, of the Alameda County Sheriff's Posse and 1949 president, is on the right. (Courtesy MHA Archives.)

Beloved Aahmes Shrine Rangers captain Wally Souza is shown with his black-and-white Pinto. Wally was a key member of the MHA during the 1960s and 1970s. He and his wife, Mary, now live in Jamestown. (Courtesy Mary Souza.)

Boots and Jeans officers Pres. George Hower (left, riding King) and Capt. Dutch Cummings (right, riding Golden Sis) are shown in the 1950s. King and Sis were a matched pair of square-dance horses. The group held their weekly practice sessions at Skyline Ranch to the delight of local onlookers. (Courtesy MHA Archives.)

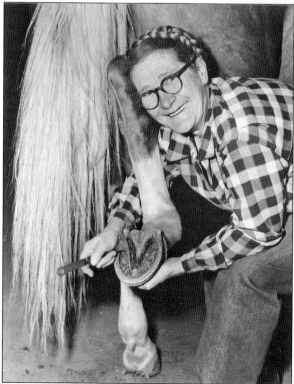

Beloved Oakland horsewoman Ethel Colbert is shown as most people remember her. She was honored in 1971 with the Groom of the Year Award from the Pacific Coast Hunter Jumper and Stock Horse Association. The award was originally sponsored by Patsy (Dr. Gerald) Gray, as a tribute to her longtime manager, trainer, and groom, Joe Shroyer. Ethel received a standing ovation when the award was presented. She was profoundly deaf since her birth in 1897. (Courtesy Loretta Cosca.)

Fr. Ed Gallagher was an active trail rider in the East Bay hills prior to his death in 1966. While serving as a Catholic priest at St. John the Baptist Church in San Lorenzo, he rode his Morgan horse on his days off. He enjoyed trail rides, both locally and in the high Sierra, with friends from the Aahmes Shrine Rangers and the Alameda County Sheriff's Posse. (Courtesy Fr. Daniel Cardelli.)

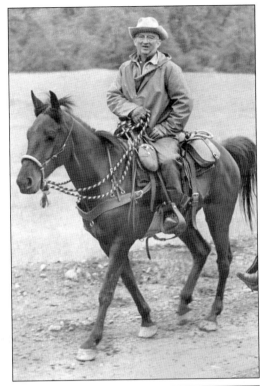

Oakland's Olympian, Howard "Chan" Turnley, trained with Cornelia Cress at Mills College in the 1950s. Following years of diligent practice, he was chosen for the U.S. Olympic equestrian team for the 1960 Olympic Games in Rome. Chan was active with the MHA in the 1960s and 1970s and now lives in the Montclair district. (Courtesy Chan Turnley.)

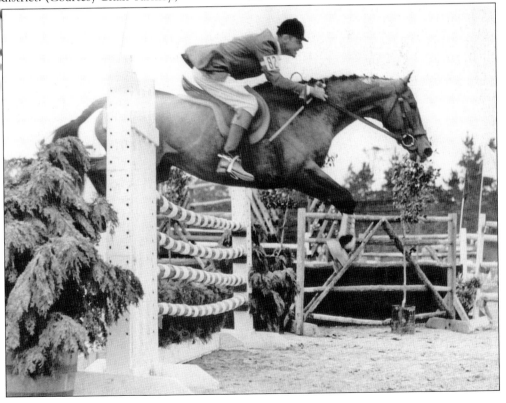

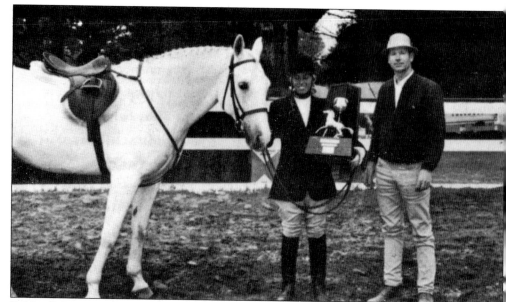

Debbie DeMartini, with her horse, Earl's Court, accepts the First Annual Erling Hansen Perpetual Trophy from Earl himself during the MHA Gold Cup horse show. The award was presented to Debbie as the high-point rider at the first annual show in June 1969. (Courtesy MHA Archives.)

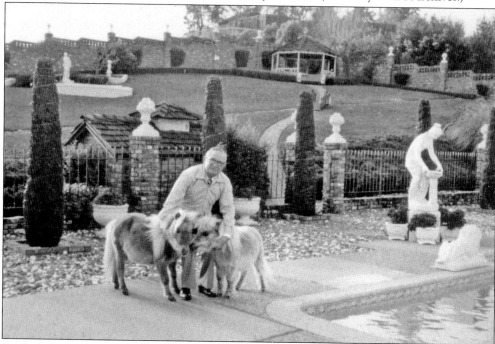

Rayford Ely, a downtown auto dealer, resided at 5433 Fernhoff Drive with his wife, Hazel, and a herd of miniature horses until the mid-1980s. The Elys had several acres of lawn behind a wrought-iron fence. A parking area was provided nearby so that local parents could bring children to enjoy the little horses. Ray and his wrangler Danny would load them into a minivan from which the seats had been removed. Thus they "trailered" to schools, convalescent hospitals, and wherever people would enjoy the fluffy little animals. (Courtesy Marlon Willson Oakley.)

Mary and Harry Dunn acquired the Aahmes Shrine stables from the Bemis and Brown families in 1973. They renamed it Vista Madera Stables. The Dunn family offered stall and paddock boarding for $25 to $40 per month. The place was sold to the City of Oakland in 1994 to become City Stables. Still the name endures as Vista Madera Feed and Tack. Kathy Dunn, daughter of Mary and Harry, operates her equestrian emporium as an unofficial community center. It was there that the seed for this book was planted. (Courtesy Kathy Dunn.)

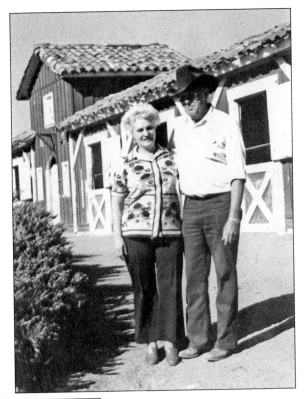

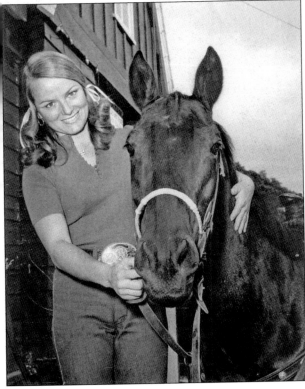

Vivian Troxell Graham grew up in the Oakland horse world and rode at Green Barn, Piedmont Stables, and Skyline Ranch. She served as a handler for Charlie O at Oakland A's games in the 1970s. Later she married Jeff Graham, son of Lloyd Graham Donaldson and grandson of Beatrice Graham. Jeff and Vivian operated the Skyline Silversmiths shop at Skyline until 1984. Here she appears with Drifty in a photograph from 1972, when she was chosen as the Rowell Ranch Rodeo Queen. She is now a rancher near Lincoln, California. (Courtesy Vivian Troxell Graham.)

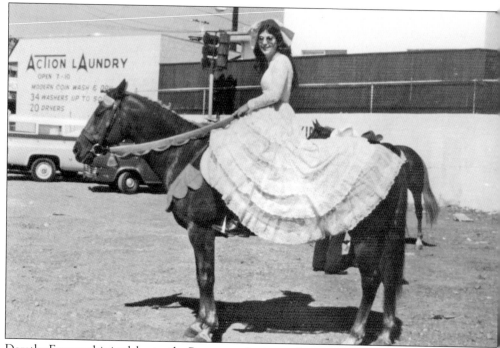

Dorothy Franceschini celebrates the Portuguese heritage of many of Oakland's equestrian pioneers for the Laurel District Merchants' Parade in 1977. Dorothy, who was a longtime boarder at the White Barn, now lives in San Leandro with her family. (Courtesy Dorothy Franceschini Rohrer.)

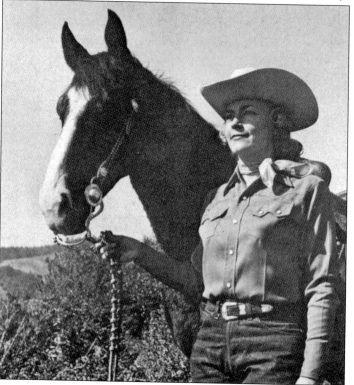

Jan Hansen grew up in the Oakland foothills. As a girl living on Calaveras Avenue, she would roller skate down to the Ming Quong orphanage at Mills College to socialize with the Chinese girls there. She married Erl Hansen while her family lived at Leona Stables. Later she became president of the Lari-ettes. She is shown with Tarda, owned by fellow Lari-ette member Buckie Johnstone. Jan and Erl now live in the Grass Valley neighborhood. (Courtesy MHA Archives.)

Nine

THE ORGANIZATIONS

According to MHA lore, the clubhouse at 10050 Skyline Boulevard was trucked up the hill in two sections from the Himmelman property in 1954. The site had been used as a wildland fire station for many years. The original firehouse was destroyed by a falling tree. After the Sequoia Arena was constructed across the road in 1948, firemen enjoyed helping at horse shows and became friendly with Gus Himmelman. With the coming of the freeways, Gus and Elsa bought a house on Maynard Street near the old Leona Stables site. It is believed that firemen moved the clubhouse to the present site, although there are no official records to confirm this. The clubhouse was used by the fire department for several years. The bathrooms have multiple showerheads. (Courtesy MHA Archives.)

The MHA Junior Relay Team is shown accepting a trophy at the Cow Palace in 1950. The riders, shown from left to right, are Ronnie Dunniway, Bill Barnard, Bernie Cummings, Ward Gallo, and Pat Wirt. Standing is their director Kay Walling, who later became president of MHA. (Courtesy MHA Archives.)

The MHA Junior Color Guard poses for a c. 1966 photograph at the recently opened Chabot Equestrian Center. The riders, from left to right, are Joan Johnson on Missy, Noelle Dawe on Oliver, Jacky Mosi on Sis-A-Lee, and Kris Goetz on Champ. (Courtesy EBRPD Archives.)

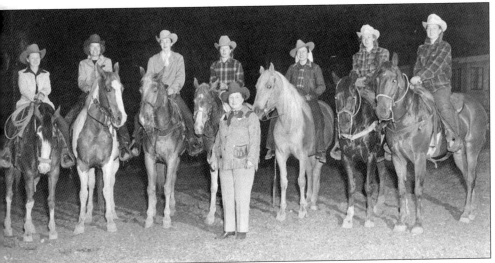

This May 1, 1946, photograph shows the founding members of the Lari-ettes at the Pinto Ranch. From left to right are Tiny Black on Rabbit, Nell Wilkie, Sylvia Brooks, Gloria Isola, Pres. Elsa Himmelman (standing), Elsa Xavier on Shasta, Mary Holmes, and Pat Funk. The Lari-ettes club remained active through the late 1960s. (Courtesy Tiny Black.)

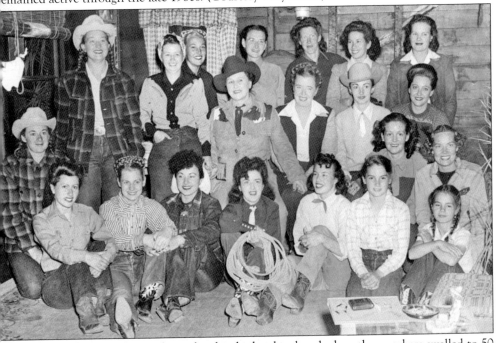

The club was very popular, and membership had to be closed when the numbers swelled to 50 riders. The group held their riding meetings at Himmelmans' Ranch, and their clubhouse was at the Pinto Ranch. While the group was primarily a social club, they rode in local parades. From left to right are, (first row) unidentified, Virginia Patten, Elsie Long, Margo Black, unidentified, Loretta Cosca, behind Loretta unidentified, Nell Wilkie, and in front a young Joyce Cosca; (second row, kneeling) Mary Holmes, Elsa Himmelman, unidentified, Sylvia Brooks, and Geneva Menecucci; (third row, standing) Pat Funk, Tiny Black, Carmel Himmelman, Agnes Yaegar, Margaret Rukavina, Emily Tosti, and Florence Cosca. (Courtesy Loretta Cosca.)

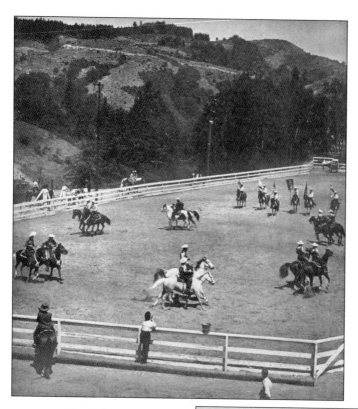

The immensely popular Boots and Jeans Square Dancers on horseback are shown in a dress rehearsal at Skyline Ranch in September 1950. Capt. Lefty Bowers was directing from the corner of the arena and is not visible. The dancers performed at numerous events and even appeared on television on the KGO *Bay Window* program on November 25, 1955. (Courtesy MHA Archives.)

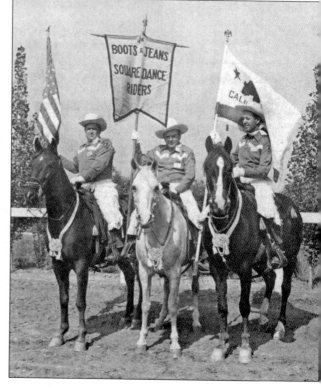

The Boots and Jeans Square Dance Riders Color Guard is shown here in 1954. The riders are, from left to right, Shorty Galer, Larry Domina, and Lefty Bowles. The group held their practice sessions one night a week at Skyline Ranch, and numerous local horsemen turned out to watch. (Courtesy MHA Archives.)

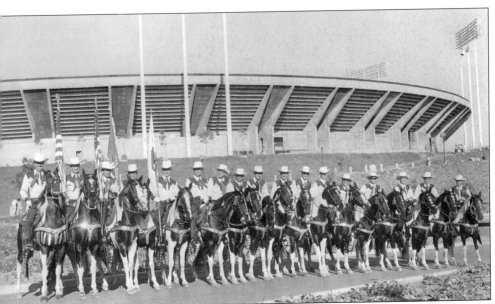

The Aahmes Shrine Mounted Patrol drill team pauses for a photograph on September 8, 1966, opening day of the Oakland Coliseum. The patrol was always a crowd-pleaser, performing their intricately executed drills on their flashy black-and-white Pintos wearing shiny silver saddles. The Shriners were the only team in the world using matching Pintos. They won numerous awards in parades and drill-team competitions. (Courtesy Terry Tobey.)

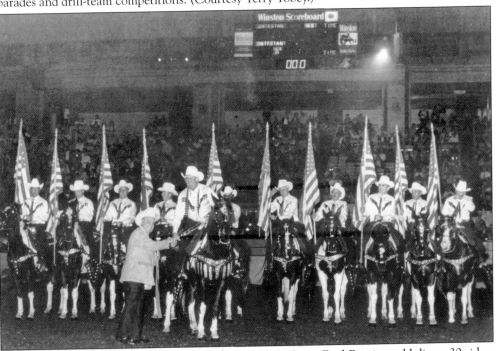

More than a half century after the glorious days when Capt. Fred Bemis could direct 30 riders on black-and-white Pintos in synchronism, the Aahmes Shrine Rangers continue to delight audiences. Here they accept a trophy at the Grand National Rodeo at the Cow Palace in San Francisco in 1982. (Courtesy Hugh Gregg.)

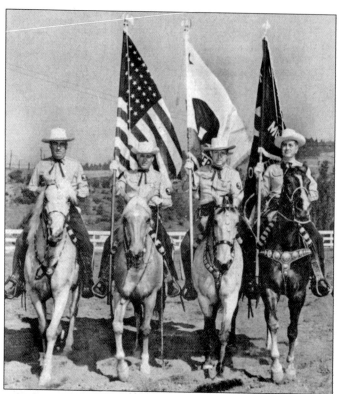

This photograph, taken in 1954, shows the newly appointed 1955 officers in the Alameda County Sheriff's Posse. From left to right, the riders are former captain Walt Garvey, Capt. Joe Merritt, 1st Lt. Rod Williams, and former lieutenant Charles Buchannon. The location is Skyline Ranch. (Courtesy MHA Archives.)

The Alameda County Sheriff's Posse takes time to pose for a group photograph during their annual camping trip at Harry Rowell's Castro Valley ranch from April 4–7, 1947. On the far left is J. L. "Marty" Martin riding Flash. Marty owned the Montclair Stone Yard. Next to him is his son Bart Martin on his pony, Crackers. Harry Rowell is believed to be next to Bart. The location was then called Maggie's Half Acre before becoming EBRPD land. (Courtesy Marian Girard.)

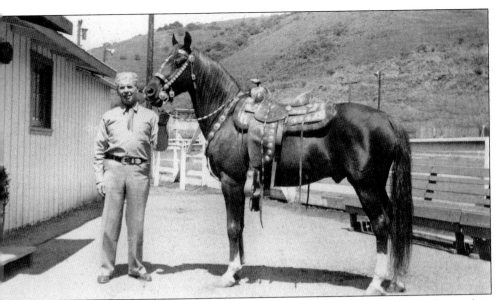

Eddie Carey was a well-liked member of the Alameda County Sheriff's Posse and was chosen their captain in 1947. Eddie lived in Redwood Canyon at the location of the current park residence. People nicknamed it "Carey's Canyon." Eddie also served on the MHA board. This photograph was taken in front of the Skyline Kitchen in the 1950s. (Courtesy Earl Hansen.)

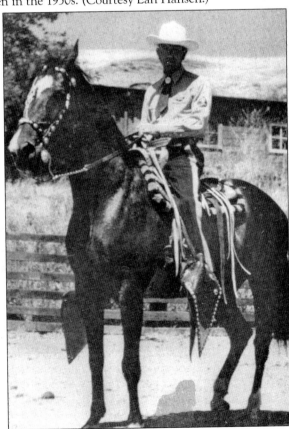

A. J. McCosker was an honorary life member of the Alameda County Sheriff's Posse. A. J. owned the largest dirt-moving company in California and ran a rock quarry on Lincoln Avenue through the mid-1950s at the present site of the Greek Cathedral of the Ascension. His father, John McCosker, pioneered an extensive hilltop ranch in the town of Canyon. Dwayne, son of A. J., recalls trailering with his father to posse drills every Thursday night at Miss Graham's Redwood Riding Stables. A. J. was a very active member of the posse and hosted frequent barbeques for the members at the McCosker Ranch. (Courtesy Dwayne McCosker.)

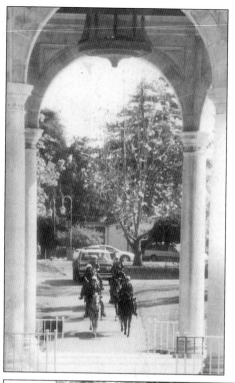

The Oakland Police Department opened its barn at Lakeside Park in 1981, backed by the Central Business District Security Association, with five donated horses. For 23 years, officers patrolled downtown, marched in parades, and conducted horse day camps for underprivileged children. Mounted officers were required to groom, clean, and feed the horses before their patrol duty, in the tradition of cavalry discipline. In an atmosphere of budget shortfalls and understaffing, the mounted unit was decommissioned in 2004, despite the outcry from Grand Lake businesses, the *Oakland Tribune*, and horse lovers. At left, the color guard parades to the Lake Merritt bandstand on opening day. Below, officers Chris Saunders and Kathy Mendez join the Reverend Chandler Stokes at the blessing of the animals at First Presbyterian Church in 2004. Officer Saunders was awarded a medal in 2006 for apprehending a gang of serial robbers. (Courtesy Oakland Police Department.)

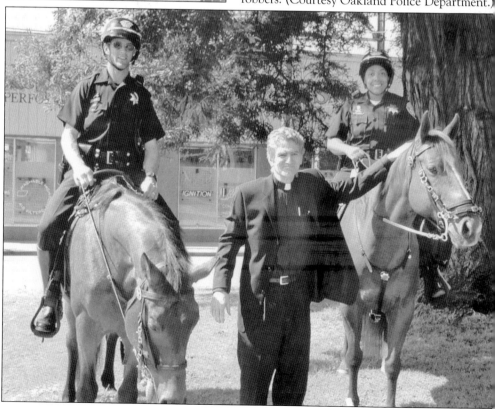

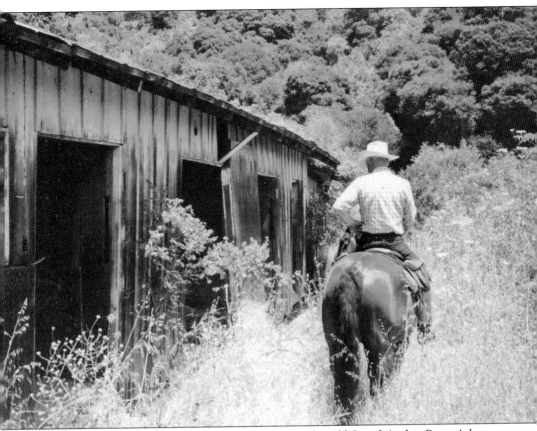

Lloyd Graham reminisces as he rides his horse Charlie past his old friend Archie Brown's barn in this poignant photograph taken in the 1980s. Archie has long since passed away, and his barn is slowly falling into decay. Just like the old days remembered in this book, memories are all that remain. (Courtesy Lloyd Graham.)

ACROSS AMERICA, PEOPLE ARE DISCOVERING SOMETHING WONDERFUL. THEIR HERITAGE.

Arcadia Publishing is the leading local history publisher in the United States. With more than 4,000 titles in print and hundreds of new titles released every year, Arcadia has extensive specialized experience chronicling the history of communities and celebrating America's hidden stories, bringing to life the people, places, and events from the past. To discover the history of other communities across the nation, please visit:

www.arcadiapublishing.com

Customized search tools allow you to find regional history books about the town where you grew up, the cities where your friends and family live, the town where your parents met, or even that retirement spot you've been dreaming about.

MAP SEARCH